The
PAINT
POURING
Workshop

The PAINT POURING Workshop

Learn to *Create* Dazzling Abstract Art *with* Acrylic Pouring

MARCY FERRO

FOUNDER OF MIXED MEDIA GIRL

LARK
New York

New York

An Imprint of Sterling Publishing Co., Inc.
1166 Avenue of the Americas
New York, NY 10036

ISBN 978-1-4547-1112-4

Distributed in Canada by Sterling Publishing Co., Inc.
c/o Canadian Manda Group, 664 Annette Street
Toronto, Ontario, Canada M6S 2C8
Distributed in the United Kingdom by GMC Distribution Services
Castle Place, 166 High Street, Lewes, East Sussex, England BN7 1XU
Distributed in Australia by NewSouth Books
University of New South Wales, Sydney, NSW 2052, Australia

For information about custom editions, special sales, and premium and corporate purchases, please contact Sterling Special Sales at 800-805-5489 or specialsales@sterlingpublishing.com.

Manufactured in Canada

6 8 10 9 7 5

sterlingpublishing.com

Cover and interior design by Shannon Nicole Plunkett
Principal photography by Tim Sabatino;
Additional project photography by Christopher Bain: 100, 104, 106, 110
Canvas texture by Dmytro Synelnychenko/iStock/Getty Images

Contents

Introduction

Have you ever wanted to try acrylic pouring but just don't know where to start? What materials do you need? What are the materials for, and how are they used? Can you use items and products you already have in your house? These and many other questions are answered in this book.

Acrylic pouring, also known as fluid painting or pour painting, is a unique form of art using the fluidity of acrylic paint to create beautiful pieces of abstract art. After years of trying various art techniques, including oil painting, mixed media, and watercolor painting, I came across acrylic pouring in videos online. I was immediately enthralled with the amazing colors and effects of fluid paints and just had to try it! I began experimenting with the techniques and realized what a fun, creative outlet acrylic pouring can be.

While acrylic pouring does take practice, it is an art form that doesn't require years of study and training to get amazing results. With so many easy and fun techniques, this art form is really for anyone who loves to create. It is a great activity to enjoy with friends and family and is an excellent way to relax or de-stress! One of my favorite things about paint pouring is that you will come up with a unique piece of art each time, and the result always has an element of surprise, even when you're using a specific technique.

The Paint Pouring Workshop is for beginners who want to get started with acrylic pouring as well as more experienced acrylic pourers simply looking to learn some new techniques to add to their arsenal. With acrylic pouring, you can create beautiful paintings and projects such as vases, clocks, jewelry, and more. The tutorials in this book are hands-on, so you will be making cool pieces of art while you're learning about acrylic pouring. This book covers all the tips, tricks, techniques, troubleshooting, and safety guidelines that I have learned through many experiments and some trial and error. You'll find everything you need to know to get started and to achieve paint-pouring success.

The Basics

Before you learn some of the fun techniques, I'll cover the basics of acrylic pouring. Here you'll learn the theory and practical application of everything you need to know to get started with acrylic pouring, including materials, any necessary tools, setting up your work space, paint mixing, and more. Refer back to this section as often as needed to see the different paint pouring supplies you can use, check out mixing recipes and color combinations, and ensure you get the right consistency for your paint mixtures.

WHAT IS PAINT POURING?

Paint pouring, also known as acrylic pouring or fluid painting, is a method of abstract painting using the fluidity of paint to create free-flowing, marbleized artwork. Most acrylic paints are not fluid enough for pouring, so a large part of the paint pouring process involves mixing your paints until they reach a consistency that allows movement. Acrylic pouring can create many different effects, particularly cells, which are unique to fluid painting and often a desired effect. Cells are organic, roundish shapes created in the paint by air bubbles or differences in paint densities. For best results, a pouring medium is usually added to your acrylic paints with a small amount of water. You can also use various additives with the acrylic paint to create different effects and looks.

While acrylic pouring is currently a very popular painting technique, it has been around for quite some time. It is thought to have been created by Mexican artist David Siqueiros in the 1930s. Many artists throughout history, from Jackson Pollock to Stanley William Hayter, have used various forms of fluid painting, resulting in many of the pouring techniques we have today. Acrylic pouring is relaxing and fun and continues to spark creativity in artists of all types.

MATERIALS

There are many possible materials you can use for paint pouring, but keep it simple when you're first starting out and add to your toolbox as you go along. Most materials can be found at your local

art store, though some items, such as silicone, may need to be purchased online.

Quick Start Guide

While this section covers a wide variety of materials you can use, you may just want to skip all that and start painting right away. Here is the most simplified materials list. It contains things you probably already have, so feel free to skip the theory and jump right to Mixing Your Paint (page 13), if you're the impatient type like me! (For a more comprehensive tool kit, see page 9.)

- Canvas, wood board, or tile
- Any acrylic paint
- Any liquid glue
- Water
- Gloves
- Containers for mixing and pouring paint
- Stir sticks

Acrylic Paint

Acrylic paint is a fast-drying, water-based paint that can be used for a wide variety of art projects. There are many types and brands of acrylic paints that you can use for acrylic pouring, each with their own unique qualities. As a general rule, any acrylic paint will work, though some are better than others. To save money, I recommend starting out with craft paints during your initial practice paint pours, then graduating to artist-quality paints. Once you've practiced using different brands and types of acrylic paint, you will notice a vast difference in brightness and color between higher quality paints for artists and lower quality paints.

When you're first starting, I recommend using primary colors—blue, yellow, and red—along with white and black. With the basic colors, you can mix almost any other color you'd like. You will usually go through white and black the most quickly, so it's beneficial to purchase those colors in larger quantities.

The type of acrylic paint you use is your personal preference. You don't have to use only one kind of paint, even within the same painting. You can mix and match as many types as you want. Here are some examples of types of paint that you may see. (The labels on the paints will generally specify the type on the front of the container.)

Fluid or High-Flow Paints

These acrylic paints are highly pigmented and fluid, meaning they are more liquid and flow more easily. They are great for acrylic pouring, as their colors are bright and bold, and their consistency greatly eliminates the need to add water or another thinning agent. Due to their high quality, they can be more costly.

Heavy Body Paints

Most paints that come in a tube are considered heavy body. These acrylic paints are very thick and generally highly pigmented. Heavy body paints are primarily used in traditional acrylic painting, but they can also be used in acrylic pouring. Due to their thick texture, it may take some extra work to get them to mix properly.

Student Grade Paints

The quality of student grade paints falls in between

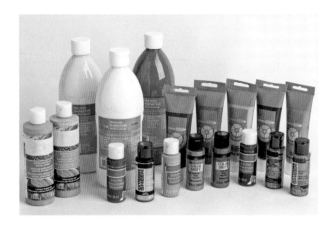

craft paints and professional artist paints, making them great for both practice and finished paintings. Student grade paints are generally inexpensive, and some colors are nearly as bright and bold as those of professional grade paints.

Craft Paints

Craft paints can be very inexpensive and are excellent for practicing when you're first starting out. The craft paint category includes poster paint, tempera paint, and children's paint. Craft paints are lower quality and less pigmented, so you generally need to use more paint in your mixture to maintain its integrity and color. Not all craft paints are acrylic; while great for practice, they may not be as long-lasting. Whenever possible, I recommend using acrylic paints only.

Matte or Glossy Paints

Matte and *glossy* are terms that refer to the shine of the paint. Matte paints will dry flat (with no shine) unless you combine them with a medium that dries glossy. You can always use a gloss varnish to create a shiny surface once the paint is dry. Glossy paints will dry with a sheen. I generally prefer glossy paints over matte paints, as the colors tend to be brighter once the painting is dry.

Opaque, Translucent, and Transparent Paints

Opaque, *translucent*, and *transparent* are common words used to describe how much light can pass through the paint. Opaque paint allows no light through and looks solid. Translucent, also known as semi-opaque or semi-transparent, paint allows some light through. Transparent paint is the most see-through and allows a lot of light through. Whether you choose an opaque, translucent, or transparent paint will usually come down to personal preference.

Additional Paint Options

When getting started with acrylic pouring, you may want to use paints that you have around your home, or paints that may be easier to acquire if you aren't near an art store. For example, leftover house paint makes a great option.

You may also want colors or effects that you don't get with regular acrylic paints. Metallic paints are a fun option to add an extra-special touch to your pour. They tend to create more cells. You can also find glitter paint, neon paint, glow-in-the-dark paint, and many others. The options for acrylic paints are endless. Practice with what you have on hand or with inexpensive paints, and have fun!

Pouring Mediums

Pouring mediums are an essential component of acrylic pouring. They help the paint flow easily on a flat surface, keep the colors from mixing and becoming muddy, and prevent the paint from cracking (also known as crazing) when drying. Pouring mediums possess different qualities that will affect the cells of your painting, assist your

paint with self-leveling (the process in which the paint becomes smooth and flattens out on a surface), and produce other results that you may or may not want. There are many options for pouring mediums, which you can find at an art supply store, hardware store, or online, no matter where you are.

You can paint pour with a mixture of just paint and water. However, there is a greater risk that your paint will crack because water weakens the integrity of the paint. If you do choose to try pouring with just water, follow this firm rule: make sure your mixed paint never contains more than 30 percent water. For example, if you're mixing 10 fluid ounces (296 ml) of paint, you would combine 3 fluid ounces (89 ml) of water and 7 fluid ounces (207 ml) of paint.

Glue

Glue is a great pouring medium to start with. You can use almost any liquid glue, including white school glue, clear glue, or multipurpose glue. As with any material, different brands of glue vary in quality. Certain glues, such as some book-binding glues, are archival and designed to last, making them a higher quality option, and often more expensive option, than school glue.

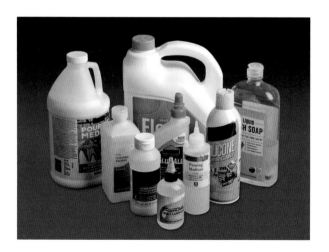

Latex-Based Paint Conditioners

Paint conditioner is designed for house painters. The conditioner is mixed with the paint to help it flow, fortify the paint, and prevent it from cracking. Paint mixed with this medium is also self-leveling. I usually use Floetrol®, which helps you create cells without any additional additives.

Paint conditioner is inexpensive (often cheaper than glue, depending on where you live). It's available online or at most local hardware or house-paint stores. While paint conditioners weren't specifically designed for acrylic pouring, and therefore are not sold in art stores, I find them to be the perfect balance of cost and quality.

Fluid Mediums

A fluid medium, such as Liquitex® Pouring Medium, Vallejo Pouring Medium, and DecoArt® Pouring Medium™, is specifically designed to make paint more fluid and produce pours without crazing. It is self-leveling, won't affect the color of your paint, and dries with a glossy sheen, depending on what paint you are using. Some professional pouring mediums are a little on the pricey side, but they work beautifully for paint pouring.

Acrylic Polymer Mediums

Acrylic polymer mediums, such as Golden® GAC 800, are intended to increase the fluidity of acrylic paints without crazing. They are much tackier than fluid mediums, and paint mixed with an acrylic polymer medium can adhere to multiple types of surfaces. It dries glossy (I have found this to be the case, no matter what type of paint I was using). Because it is intended for professional artists, it's also on the more expensive side.

I recommend trying out as many pouring mediums as you can to find your favorite. Some artists even like to mix mediums to create their own formula. For example, you can combine glue, Floetrol, and GAC 800 in a bottle and use this as your pouring medium, mixing it with your paint and water as needed. Learn what works best for you with the materials you have available.

Storing Your Supplies

Acrylic paints and mediums can last several years, depending on their quality and how you store them. They should be kept sealed in a cool, dry environment. Professional acrylic paints and mediums should have a shelf life of at least five years, while craft acrylic paints will last much shorter.

If you notice that your paints or mediums are drying out or becoming rubbery or clumpy, they likely have gone bad and will need to be thrown out. They can also develop a sour or moldy smell.

To avoid having your paints go to waste, ensure you buy in the correct quantities, seal all containers fully, and use up your supplies in a reasonable amount of time. Should your materials go bad, let them dry out by leaving them open before putting them into the trash. If you are using house paints, look into recycling the paint containers instead of throwing them away.

Silicone and Other Oils

You can add silicone and certain oils to your paint mixture to assist in creating cells. The acrylic paint rejects and pushes against the silicone, causing the silicone to rise to the surface and create cells. I have found silicones to be especially helpful in cell creation when you are first starting out and working on perfecting your paint consistency. There are also certain pouring techniques, such as Swiping (page 47), where silicone can make a big difference and give you some fun effects. While using silicone can help your paint pour produce cells, it's an optional additive. You can certainly create cells without it.

If you choose to use it, look for household products that contain silicone or dimethicone (a silicone-based polymer) to add to your paint. Many beauty products contain these substances, and most mechanical lubricants will work well. I recommend staying away from cooking oils, as they generally don't create the best results, and they can go rancid—not a quality you want in a painting. Here is a list of items that will work (though there are many, many others):

• Treadmill lubricant made with silicone

• Penetrating oil spray

• Windshield treatments made with silicone

• Multipurpose silicone lubricants

• Hair serum containing dimethicone

• Silicone spray lubricant

• Personal lubricants containing dimethicone

You need only a very small amount of a product (a couple of drops usually) to produce the desired effect. Using too much will prevent the paint from sticking to the canvas and leave craters where you can see its surface. When you finish the painting, you'll also need to clean the oil and silicone off before you can seal the piece.

─────── TIP ───────

You can add silicone to all of your paint colors, or to just one color in your pour. You can thoroughly stir the silicone into your paint for smaller cells, or add it and very lightly stir for larger cells.

Additional Paint Additives

Other additives that are occasionally used to help create cells—and that most people generally have around their home—are isopropyl alcohol (91 percent tends to work best) and dish soap. To use isopropyl alcohol, omit water and mix it into your paint right before pouring (alcohol evaporates quickly). To try out dish soap, add a few drops into your water and then mix the soapy water into your paint.

Surfaces for Painting

There are many types of surfaces that you can use for paint pouring. In fact, after a while you might find yourself wondering, "What else can I pour on?" I'll go over some of the most readily available and commonly used surfaces for fluid painting, as well as some of the pros and cons of each.

Watercolor, Mixed Media, and Canvas Paper

These thick papers are designed to be used with liquids and regular paints and usually come in pads of 20 sheets. They are great for practicing, as they are fairly inexpensive. You can also use them to make cards, jewelry, and frame mats. However, keep in mind that the paper will warp, so you will need to flatten it out after it dries, or frame it. To flatten, let your piece fully dry, cover the top with parchment paper to protect the paint, then weigh it down with heavy, flat objects, such as books or pieces of wood. This should flatten your piece within a few days.

Canvas Panels

Canvas panels consist of canvas fabric wrapped around a flat board (typically cardboard). They are great to practice with, as they are inexpensive, don't take up much space, and are easy to find. They are also very easy to frame.

One potential problem with using canvas panels is that the moisture from the paint might warp the cardboard which can be very difficult to flatten back out. When needed, you can smooth out a canvas panel after it is fully dry by laying it on a flat surface, covering the top with parchment paper to protect the paint, and weighing it down with a heavy object, such as a board or a book.

Stretched Canvas

Stretched canvases come in different price points and sizes and vary in quality, from economy to gallery quality. You can find canvases in virtually any size, from 1 × 1 inch (2.5 × 2.5 cm) all the way up to 5 × 5 feet (1.5 × 1.5 m) and bigger. Canvases

can be ordered online or purchased at your local art supply store. (Some sites even make custom canvases.)

Most art stores have their own brand of economy canvas packs, usually containing 10 or 12 canvases. I suggest practicing on these inexpensive canvases and surfaces until you have become more confident at acrylic pouring, then graduating to more expensive canvases.

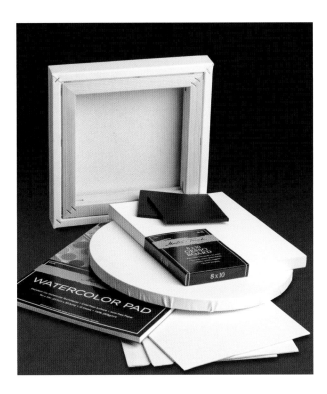

Wood Panels

Wood panels can be purchased at art stores as flat panels or with a cradle, which is a frame under the surface of the board. You can also make your own wood boards or panels from medium-density fiberboard (MDF), plywood, or other wood pieces. Wood scraps from leftover fencing, old cabinets, or shelves can be great to practice on if you have access to them.

To prevent warping and to preserve your colors, it is best to prime any wood surface before painting on it (see Surface Preparation, page 8). Some wood panels come pre-primed, though those can be slightly more expensive.

Glass and Other Surfaces

There is an endless list of possible surfaces to pour on. Here are some of my favorites:

- Tiles
- Glass vases
- Wooden or chipboard pieces
- Vinyl records
- Picture or mirror frames
- Glass in picture frames
- Furniture

Surface Preparation

Many canvases come pre-primed with gesso, which means you can go ahead and pour right on them. To add an additional layer of protection, you can add another layer of gesso onto your canvas before pouring. Gesso is a mixture of acrylic polymer, chalk, pigment, and other chemicals and is used to prepare (or prime) canvases and other surfaces for painting. It is generally white, though it can also be clear or black. While gesso is not absolutely necessary, it can help smooth out your canvas and make it less absorbent, creating a better surface for your paint to flow on.

To prime your canvas with gesso, paint the gesso onto your canvas with a brush the same way that you would normally paint a canvas. Let it dry fully and then apply additional layers as desired.

Wood panels usually don't come pre-primed, although there are sometimes exceptions. To prepare wood for pouring, use primer or gesso and paint a solid coat on your wood, letting it fully dry before pouring. This can take up to an hour depending on the temperature and humidity. You will often want to add two or three layers of primer or gesso to ensure your board is fully sealed and smooth, letting each layer dry in between.

For glass or tile, simply wipe with rubbing alcohol prior to painting. The key to pouring on glass or any smooth surface (such as tile) is ensuring it is clean and oil-free and applying a sealer to your paint after it dries (see Finishing Your Painting, page 17). Whereas one layer of sealer may be enough for a painting, I recommend sealing glass or tile with at least three layers to ensure durability.

TOOLS

There are a variety of tools you can use for acrylic pouring, depending on what technique you're using. Most tools have substitutes that you may already have around your home, or you can easily purchase them without spending a lot of money.

Mixing Containers

You will need containers or bottles to mix your paints. You can use plastic cups, metal cups, and glass jars. You'll need a separate container for each color, as well as an extra supply of cups for most of the acrylic pour techniques.

Stir Sticks

Wooden stir sticks (such as jumbo craft sticks) are inexpensive and can be dried and reused. Plastic stir sticks can also be used, washed off, and reused.

Measuring Cup

When starting with acrylic pouring, a measuring cup helps you measure the exact quantities that you need for paint mixing and get your paint to the correct consistency.

Gloves

Acrylic paint and its additives are toxic, and some are latex-based. To protect your skin, I recommend nitrile gloves, though latex or plastic will work just as well. If you have particularly sensitive skin or a latex allergy, consider heavy-duty nitrile gloves that come up above your wrists.

Torch

Torches are commonly used in acrylic pouring to remove air bubbles in the paint. I find a mini butane torch is easiest to use, and it can easily be acquired online or at your local hardware store. A cooking torch also works quite well. Consider the torch as an optional tool. If you do not have access to one, you can still create beautiful acrylic pours and get great cells without it.

Can you use a heat gun or hair dryer instead of a torch? The answer depends. Heat guns and hair dryers don't provide just heat, but also air flow. A torch just emits heat without moving the air. A heat gun, if capable of emitting low or no air, can work almost as well as a torch. Hair dryers can be used in certain acrylic pour techniques, but should not be used in place of a torch.

Offset Spatula or Palette Knife

Some acrylic pour techniques ask you to apply a solid base coat of paint. An offset spatula or palette knife can help you cover the canvas quickly and evenly.

Swipe Tools

A swipe tool is any item that can be used for the Swiping technique (page 47). There are so many options that it would be impossible to list them all, but some of my favorites include a silicone paint-scraping tool, a piece of cardboard, and a wet paper towel. You can also use scrap paper, plastic, a squeegee, or even a comb!

Paint Pouring Tool Kit

- Mixing containers
- Stir sticks
- Measuring cup
- Gloves
- Torch (optional)
- Offset spatula or palette knife
- Foam paintbrush (optional)
- Tarp, plastic sheet, or cardboard for protecting your work space
- Racks for raising and air-drying your painting

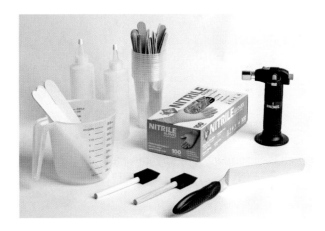

Colander

One of my favorite tools to use in acrylic pouring is a colander. You can use a colander or strainer to

create some awesome patterns in your pours (see page 75). Colanders and strainers come in so many different patterns, from circular or square holes to flower patterns, that you could spend quite some time trying out as many as you can find and seeing all the different patterns you can create!

Colanders are inexpensive and can be purchased at most dollar or general merchandise stores. You need a colander specifically designated for painting. Once you have used it for pouring, you never want to use it for cooking, even if you have cleaned it thoroughly.

Hammer or Mallet

One of the many fun acrylic pour techniques calls for a hammer or mallet (see page 59), so it is a great item to have in your toolbox. Any hammer will work, and to protect it from paint, you can cover it with plastic wrap or simply wipe off the paint thoroughly after using it.

String

I always recommend having string on hand, as the String Pull technique (page 55) can add some great effects to many acrylic pours. Cotton cooking twine works well, though other materials will also do.

SETTING UP YOUR WORK SPACE

The good news is that you don't need a lot of tools, space, or supplies to set up your work space for acrylic pouring. While paint pouring can be messy, you need as much space as the size of your canvas. Any mess can easily be contained in a pan, plastic bin, or even a cardboard box. You can also simply cover your work space with plastic and have fun.

Start with a clean space in a well-ventilated room. The space should be as free of animal hair and dust as possible. Animal hair and dust can get into your painting as it dries and create some undesired effects. Keep in mind that children and animals love to join in, even when not invited! If possible, pour in a space that is inaccessible to them.

The best area for a pour is a table, desk, or counter that is as level as possible. This is very important because you are working with fluid paint; if your surface isn't level, your paint can move in undesired and unintended directions. I recommend that you avoid pouring over a carpeted space as paint pouring can get very messy, and you run the risk of ruining your carpet. However, if you only have a carpeted area to use, just put a tarp, plastic sheet, or piece of cardboard under your work space to protect it.

You will want to have your canvas raised while pouring and while drying to allow space for the paint to run off and air to flow under the canvas for optimum drying. Various kinds of racks, such as wire cooling racks, can help you accomplish this. Alternately, you can elevate your canvas with cups

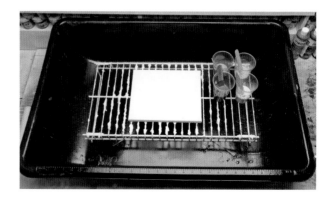

Conserving Supplies

Once you get started with paint pouring, you generally don't want to stop. As a result, you might go through a lot of paint, cups, and stir sticks. While plastic cups and wooden sticks can be recycled, there are other ways to reduce waste as well.

Choose Reusable Containers

Premix the main paint colors you use in large plastic squeeze bottles as opposed to individual cups. You can even reuse old plastic water bottles or glass jars for this. Reusing containers will save you tons of money and also prevent a lot of waste. Premixed paint, depending on what pouring medium you use, will generally last for about a month.

Reuse Cups and Sticks

Cups and stir sticks can also be reused. Once paint in a cup has fully dried, it is usually very easy to peel off. Keep in mind that if you have previously used silicone in your cup, the silicone will remain in the cup and affect future pours, even after you remove the paint. You can also wash your cups to clean out the paint, but I recommend doing this minimally and only if you have a utility sink. Paint can clog your drain and is not environmentally friendly. If you choose to wash out your cups, just rinse them with water until clean. Wood sticks can be dried and reused, or you can use plastic sticks and peel the paint off once it's dry.

or even by simply putting pushpins into the corners of your canvas frame.

Acrylic paint is water-based and, therefore, easy to clean up, should any drips get outside of your work space. On nonporous surfaces, such as tile and marble, you can wipe the paint off easily while it is still wet, or gently scrub it or peel it off if it has dried. On porous surfaces, such as cloth or carpet, you will want to clean any paint off while it is wet. Generally, soap and water will do the trick.

While you can acrylic pour just about anywhere, the ideal setup consists of a perfectly level surface, a bin to catch the paint, and a rack inside the bin to hold the painting. This keeps the mess to a minimum. It's easy to maintain and clean, and it's even transportable.

———————— TIP ————————

You can place parchment or plastic on the bottom of your bin to catch the paint runoff. Once this dries, you can peel off the dried paint, known as acrylic skins, and then use them for other projects (see page 109)!

Drying Area

You can leave your painting on your painting rack to dry, if you're using one. You will want to put plastic or parchment paper directly between your canvas and your rack so that the canvas doesn't stick to it. However, you might be having so much fun that you just want to keep going. For that reason, it can be very beneficial to set up a separate drying area.

Your drying area can consist of counters, shelves, or racks. If you're short on space, try using a baker's rack or something similar with close-together shelving. Make the most of the space you have and upgrade later, if desired. The most important feature of your drying area is a level surface. An unlevel surface will cause the paint to run off while drying. It can be extremely disheartening to create a beautiful painting, and then come back the next day to find some of the paint has run off the canvas and you have lost your beautiful design.

It is important to let your paintings dry in a somewhat temperature-controlled environment. Too cold and your paintings will take a long time to dry, and too hot and your paintings are more likely to craze. The ideal temperature is between 60°F and 75°F (15°C and 24°C).

Lastly, pay attention to possible contamination. Bugs, dust, animal hairs, and other particles can get into your painting while drying. Do your best to keep animals and children out of your drying area and, ideally, have your wet paintings protected by a screen or wall of plastic while they dry.

———— TIP ————

A painting needs to "breathe" while it dries, so don't put it in a space where it is completely sealed, such as a plastic bin with a lid. It will not dry properly there, and your surface, such as the wood frame on your canvas, can warp.

Safety

Though acrylic paints are generally safe to use, most acrylic paints and mediums are made with toxic chemicals. I'll cover some important safety tips and precautions to keep in mind when using acrylic paints, mediums, and some of the tools used for pour painting.

- Acrylic paints and mediums can release fumes, so it is best to pour in a well-ventilated space, or even use a mask or respirator if you are particularly sensitive. Because of their toxicity, it's best not to get acrylic paint or additives on your skin, and I highly recommend wearing gloves. Should you get acrylic paint on your skin, it can easily be washed off with soap and water. It is rare, but if you notice any form of allergic reaction, such as itchiness or redness on your skin, consult a health-care professional.

- Acrylic paint can stain clothes and fabrics. Take care to wear clothing you don't mind getting paint on, or use an apron. Should you get acrylic paint on fabric, carpet, or other cloth, wash it *immediately* with soap and water. If it dries on fabric, it is very difficult or impossible to wash out.

- If you plan on using a torch, keep fire safety in mind. Torch in a well-ventilated area, have a fire extinguisher nearby, and do not use it near anything flammable (such as papers or chemicals). Be careful not to overtorch, as you can burn your paint or, worse, set your canvas on fire. Additionally, if you're using rubbing alcohol in your pour, wait a few minutes for it to evaporate before torching to avoid setting the alcohol on fire. (Alcohol evaporates very quickly, so fire should rarely be an issue as long as you remember to wait a while.)

- Everyone has different health needs, and only you know what's best for you. Use your best judgment when using paints, chemicals, additives, and varnishes. If you are unsure of your specific needs, seek the advice of an appropriate professional or specialist.

- Should your pets or children get any of your paint pouring products on their skin, wash the affected area with soap and water, and watch for any allergic reactions. If any of your supplies are ingested, follow any first-aid instructions on the bottles' labels and call Poison Control.

MIXING YOUR PAINT

Mixing your paint to the correct consistency is the key to acrylic pouring and makes all the difference if you want cells in your acrylic pours. Using paint that is too thin can muddy your colors and cause you to lose your cells; using paint that is too thick can make it difficult to pour and can cause it to crack as it dries.

Of all the aspects of acrylic pouring, from supplies to techniques, paint mixing should be the one that you spend the most time perfecting. Practice with various paints and mediums until you have figured out the combinations that work best for you. With a little patience, your acrylic pours will come out beautiful every time.

Recipes

Because there are so many different types of paints and mediums, and each one has a different viscosity (the consistency and flow of a liquid), there is no one magic recipe to ensure your paint is the correct consistency. On the next page, you will find several different paint, medium, and water combinations that have performed well for me. Each of the recipes below was created using the brand of pouring medium listed in parentheses. If using another brand, the ratio of paint to pouring medium will possibly be different, but these recipes should give you a good starting point that will work for most pouring mediums and paints. The recipes here will work for most medium-body acrylic paints. You might need to adjust the amount of water if you're using a different type of paint. Craft paints will need more paint and less water; heavy body paints will need less paint and more water.

How you mix your paint will largely depend on what type of paint and medium you're using, but there is a general process that you want to follow. Always start by combining your paint and medium first. After you have mixed those together until completely blended, add the water until your paint has the consistency of warm honey or maple syrup. If you are using silicone or oil, add that to your paint

mixture after you have thoroughly mixed together the paint, pouring medium, and water. You only need a very small amount of oil, 1 or 2 drops for approximately every 5 fluid ounces (148 ml) of mixed paint.

For Using Latex-Based Paint Conditioner

50% fluid medium (Floetrol)
30% medium-body acrylic paint
20% water

For Using Glue

30% glue
40% medium-body acrylic paint
30% water

For Using a Fluid Medium

20% fluid medium (Liquitex)
60% medium-body acrylic paint
20% water

For Using an Acrylic Polymer Medium

80% acrylic polymer medium (GAC 800)
20% medium-bodied acrylic paint

How Much Paint Do You Need?

Many people run into a common problem: not using enough paint to cover their canvas. As a result, they stretch the paint to finish their painting and end up losing their design. After much experimentation, my general rule of thumb is to use 1 fluid ounce (30

ml) of mixed paint for every 16 square inches (103 cm²) of canvas. For example, if you have an 8 × 10–inch (20.3 × 25.4 cm) canvas, you would use a total of approximately 5 fluid ounces (148 ml) of paint. If you use a 16 × 20–inch (40.6 × 50.8 cm) canvas, you would need approximately 20 fluid ounces (591 ml) of paint. This is particularly important when working with larger canvases, as it is very easy to underestimate how much paint you really need.

To save time when you want to pour, I recommend mixing large batches of your most commonly used colors and storing them in sealed containers, such as jars or plastic bottles. Premixed paints can generally last three to four weeks, if sealed. If you have mixed too much paint, you can simply use plastic wrap to cover the top of your cups, and your leftover paint should keep until the next time that you pour. Paints may need to be stirred or shaken before using again.

Layering Paints in One Container

Some techniques will ask you to pour all of your paint colors into one container. When layering your paints in a cup, you want to pay attention to the order that you add them, as colors that are next to each other will mix to a certain degree. For instance, if you pour

white into a cup and then add red as your next color, you will get pink in your finished piece. If you don't want pink to appear, you should layer at least one or two colors in between white and red to reduce the possibility of blending these colors.

CREATING CELLS

When you begin pour painting, your goal may be to create beautiful cells right away. While cells are a unique feature of pour painting, they can be elusive until you get the correct paint consistency. I recommend not worrying about cells in the beginning, but simply focusing on having fun, getting used to your materials, and getting the correct paint consistency. You can create extremely beautiful paintings that have no cells whatsoever—some fluid painters even work specifically *not* to get cells.

There are many ways you can create cells organically. Certain mediums, such as Floetrol, can assist with cell creation, and silicone and other additives will help, too. When you are trying different recipes and mediums, I recommend paying attention to the effect the medium has on cells. Silicone assists in creating cells because it contains oil, which doesn't mix with water-based acrylic. Isopropyl alcohol has a lower density than water, so it tends to rise to the surface and thus create cells.

Paint density (also known as pigment density) is another important factor to consider. Paint densities can vary from color to color and from brand to brand, but generally white is the densest. As a result, it is often used as the bottom layer in certain techniques, such as the Flip Cup (page 27). When you put white on the bottom of your cup and then flip it,

the density of white causes it to sink below the other colors on your canvas, leading to cells. It can be beneficial to research paint densities, and several brands have full lists of their paints organized by density.

Cells can also be created by whipping air bubbles into your paint. When you mix your paints, you will naturally create air bubbles. Mixing faster or more vigorously can create more air bubbles; if you do your pour immediately after this vigorous mixing, you might see more cells. (Conversely, if you don't want cells, mix your paints gently and let them sit for several hours or overnight to let the air bubbles dissipate.)

A torch creates cells by quickly removing the air bubbles in paint, which usually forces the paint

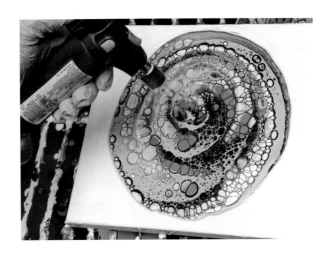

to separate, rather than letting the air dissipate slowly on its own. For best results, use the torch immediately after adding your paint to your canvas and before any tilting.

How to Use a Torch

Torches come in many shapes and sizes, can be purchased from your local general or hardware store, and are fairly easy to use. Here you will find some instructions to use them for acrylic pouring. Before you get started, be sure to fully read all instructions and safety tips accompanying your specific torch.

1. Keep the torch about 1–2 inches (2.5–5.1 cm) above your canvas. Holding the torch too close can burn your paint or cause it to crack.

2. Quickly sweep the torch back and forth over your canvas. Do not hold the torch in any one spot for more than a second or two.

3. If needed, go back over any spots where you still see air bubbles.

——— TIP ———

Remember, it is almost never the materials you are using, such as the brand of paint, that prevent you from creating cells or leave a mess on your canvas. In most cases, the consistency of your paint mixture is the cause of the problem. If you are having issues, work first on getting the consistency of your paint right before worrying about anything else.

COLOR THEORY

When painting, you will find that it is helpful to know some color theory. Color theory consists of a simple set of guidelines that tell you which colors go well together visually. While there is virtually an endless amount of information on this, we are going to just touch on the basics briefly.

Generally speaking, there are two types of colors: warm and cool. Warm colors are those such as red, yellow, and orange. Cool colors are those such as blue, green, and violet. There are many colors in between, and there can be warm and cool shades of the same color. For example, a more reddish purple is warm, while a bluish purple is cool.

You have the option of buying a ton of different paint colors or getting just the primary paint colors (red, yellow, blue) and mixing your own secondary colors (orange, green, purple) and additional hues. You should also always have white and black on hand to maximize the variations of colors available to you.

When acrylic pouring, it is helpful to stick with either cool colors or warm colors within the same painting, rather than mixing the two, until you are more comfortable and knowledgeable about how your colors will react together. Keep in mind there

are also earth tones, metallic tones, and neon colors that can be categorized as warm or cool.

Most techniques in this book will call for four or five colors of your choosing. Four colors are often plenty. I've listed a few of my favorite color combinations for you to use as a starting point.

3 or 4 neon colors of your choice

Black

Gold

Black

White

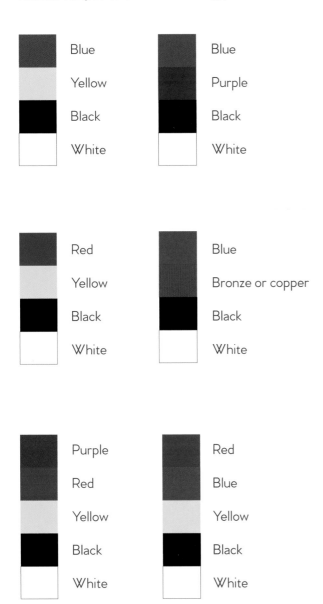

Blue

Yellow

Black

White

Blue

Purple

Black

White

Red

Yellow

Black

White

Blue

Bronze or copper

Black

White

Purple

Red

Yellow

Black

White

Red

Blue

Yellow

Black

White

FINISHING YOUR PAINTING

Now that your pour is complete, it is important to ensure that it dries safely and is sealed. In this section, I'll go over everything you need to know to properly dry and finish your painting so that your work of art is ready for display.

Drying Your Painting

You'll want to wait at least a week for your paint to dry and cure. Though the surface of an acrylic pour will take one to two days to dry, depending on the temperature and humidity, you'll need to wait a while longer for it to cure. Paint is cured when it is fully dry throughout and has hardened as much as possible. The exact cure time will depend on the climate where you live. In my experience this takes at least a week, but if you live in a humid climate you may need to wait longer, even up to three or four weeks.

Paint that is still wet will appear very glossy and reflective. Once the painting has dried, it will have lost most of its gloss and will be safe to move as needed. It is important to wait until the paint has fully cured before sealing it. Even if your painting appears dry, it may still be wet beneath the top surface. If you seal it at this point, you will trap the

moisture, which can cause your varnish to craze, become cloudy, or even grow mold.

Depending on what paint and what pouring medium you used, your colors may dull or darken as they dry. This will happen most with low pigment paints and cheaper pouring mediums, such as glue. Luckily, sealing your painting often restores the colors back to their original brightness, or close to it.

Removing Silicone

If you have used silicone in your painting, you will need to clean it off. You will be able to see silicone sitting on top of your painting in spots that appear greasy and shiny. Isopropyl alcohol or dish soap with water can usually remove it, depending on how much you've used. Apply a small amount to a paper towel or cloth and very gently clean the spots of visible silicone. You should then gently clean the entire surface of the painting to remove any silicone that you may have missed or did not see. It is very important to ensure your painting is completely dry and cured and that you clean your painting gently. Cleaning your painting before it is cured or rubbing too hard can remove some of the paint.

If you have a lot of silicone on your painting, you may need to complete these extra steps:

1. Sprinkle baby powder or cornstarch onto your canvas.

2. Using a soft brush or your hands, move the powder around and into the canvas. Let it sit for a couple of hours to soak up any oil.

3. Brush off the powder.

4. Repeat steps 1–3 as needed if you still have any oil showing.

5. Clean the entire canvas with either dish soap and water or isopropyl alcohol and a paper towel, wiping very gently to ensure you don't remove any paint.

Sealing Your Painting

Once your painting is fully dry and cured, you may want to seal it. Sealer will protect your finished piece, make it more durable, increase the brightness of the colors, and bring back the gloss of your paint. Sealing is optional, but it is recommended, particularly on any paintings you may plan to sell or give away.

There are several sealers, such as enamel or resin, and varnishes you can consider. We'll walk through the pros and cons of some of the most commonly used ones. Any of these materials can be used for any painted surface, including canvas, wood, tile, and glass.

Spray-On Sealer

There are many spray sealers and varnishes available for purchase at your local art store. These can come in matte, satin, or glossy finishes. Check the can to ensure the spray is intended for acrylic paint (some are designed specifically for oils or other types of paint). Spray-on sealer is very easy to apply, and because all you have to do is spray the sealer onto the painting, you won't leave brushmarks on your painting. You can easily add multiple coats; however, it can be difficult to apply the sealer evenly. Plus, you need to use it outside or in a well-ventilated space as it is harmful to breathe in the chemicals used in the spray.

To apply spray sealers, make sure you thoroughly read and follow the instructions on the spray can. They will tell you how far from your surface you should hold the can and how long you will need to wait for it to dry.

Brush-On Sealer

Brush-on sealers and varnishes come in just as many varieties as spray-on sealers. You apply these sealers using a paintbrush. It can be very difficult to avoid leaving brush marks on your painting's surface; however, a foam paintbrush will reduce these marks, and you can apply multiple coats to reduce or eliminate brushstrokes. Brush-on sealers are generally safe to use indoors because they aren't sprayed into the air. Once again, follow the instructions on the specific sealer that you are using to apply it correctly.

Resin

Resin is a clear liquid that turns into a glass-like substance when it dries. To use, mix your resin parts thoroughly per the instructions on the bottle, pour it on top of your cured painting, spread it around using a brush or a spatula, eliminate air bubbles with a torch (page 16), and cover the painting for 24 hours to dry. Resin tends to be a bit more on the expensive side, but it has a gloss that can be very difficult to achieve with any other sealers and can make your acrylic pour pop. Because dried resin is thicker than sealers and varnishes and forms a very solid surface, it can also make your paintings more durable.

If you used silicone or any oil, I recommend avoiding resin. Resin won't adhere to these substances and will pull away from any spots where there is any silicone or oil whatsoever.

Displaying Your Painting

Canvases and wood panels can generally be hung by their wood frames, but if desired, you can add a sawtooth hook to the back of your canvas or screw eyes and picture hanging wire. Canvas panels and watercolor paper can easily be framed and hung in the frame. (Framing them can also assist in flattening them out if there was any warping.)

Acrylic pouring can be messy, and the paint can stain the back of your canvas or other paint surface. This is not necessarily a problem, but you may want a cleaner, more professional look, especially if you're selling the paintings or giving them away as gifts. To prevent getting paint on the back of your canvas, you can tape the back edges of your canvas with painter's tape. You can also use a foam or regular paintbrush to paint a solid color of acrylic paint over the paint on the back of the canvas after your painting is dry. Another easy and nice way to finish the back of your canvas or paint surface is to glue a piece of scrapbook paper or butcher paper on the back, covering the entire back side of your canvas.

Paint Pouring Techniques

Once you have found your materials and learned to mix up your paints, you're ready to get started with the techniques! There is a wide variety of fun acrylic pour techniques to try out and experiment with. Some require additional tools, but most need only your premixed paint, some containers, and a painting surface.

There are truly as many fun techniques as there are artists. However, in this section, we will start with some of the most popular and common methods. Some techniques can be used together, such as the Flip Cup (page 27) and Negative Space Pour (page 35), but we will cover each one individually.

Feel free to experiment with your paints and come up with your own methods. The possibilities are endless! You can also try these techniques with various paints and pouring mediums to see how different materials create different results, but if you're brand-new to paint pouring, start simple and work on getting the techniques down first. Remember, silicone and other additives can be added to any of the paints used in these projects to help create cells, if desired. I've demonstrated the techniques using canvas, but other surfaces, such as wood or watercolor paper, can be used in its place. All the paintings in this section were created with Floetrol, using the paint-mixing recipe with latex-based paint conditioner (page 14).

CLEAN POUR

There are two basic types of acrylic pours: a clean pour and a dirty pour. A clean pour involves pouring individual paints in different colors directly onto the canvas instead of combining the paints in a cup first (which is the so-called dirty pour). It's a simple method for applying paint onto your canvas and is used in several other acrylic pouring techniques. It can also be used alone.

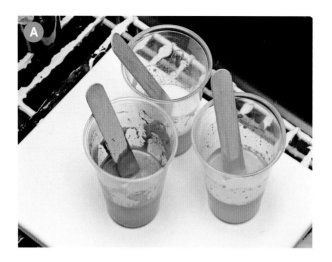

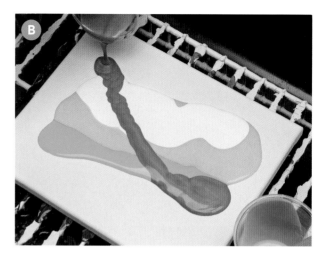

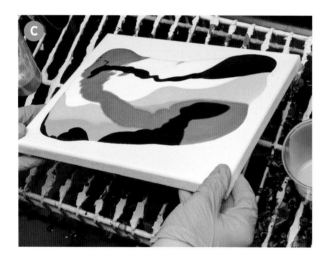

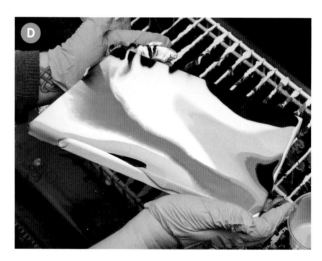

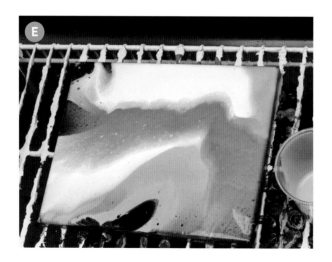

WHAT YOU NEED

Paint Pouring Tool Kit (page 9)

Acrylic paints, 4 or 5 colors of your choice

Pouring medium of your choice

Silicone and other paint additives of your choice (optional)

Canvas

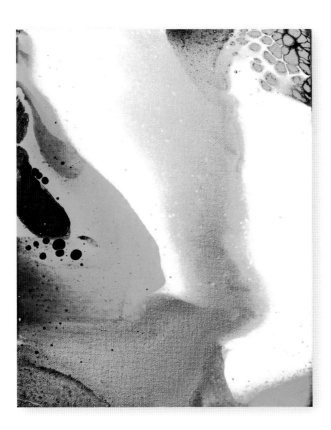

Colors used:
black, white, green, turquoise, gold

INSTRUCTIONS

1. With the instructions and recipes on pages 13–15, combine your paints with your chosen pouring medium and paint additives, mixing each color in a separate cup **(A)**.

2. Pour each color, one at a time, onto the canvas until you have mostly covered its surface **(B)**. The paints can be poured in any pattern, such as in stripes or zigzags, or randomly across the canvas.

3. Tilt the canvas in any direction you desire until the canvas is completely covered with paint **(C, D)**. Take care not to run too much paint off in any particular direction so that you can ensure you are able to cover the entire canvas.

4. Once the canvas is completely covered, set the painting on a level drying area **(E)**. Let the paint dry for at least a week, clean off any silicone, if needed, and seal it (see Finishing Your Painting, page 17).

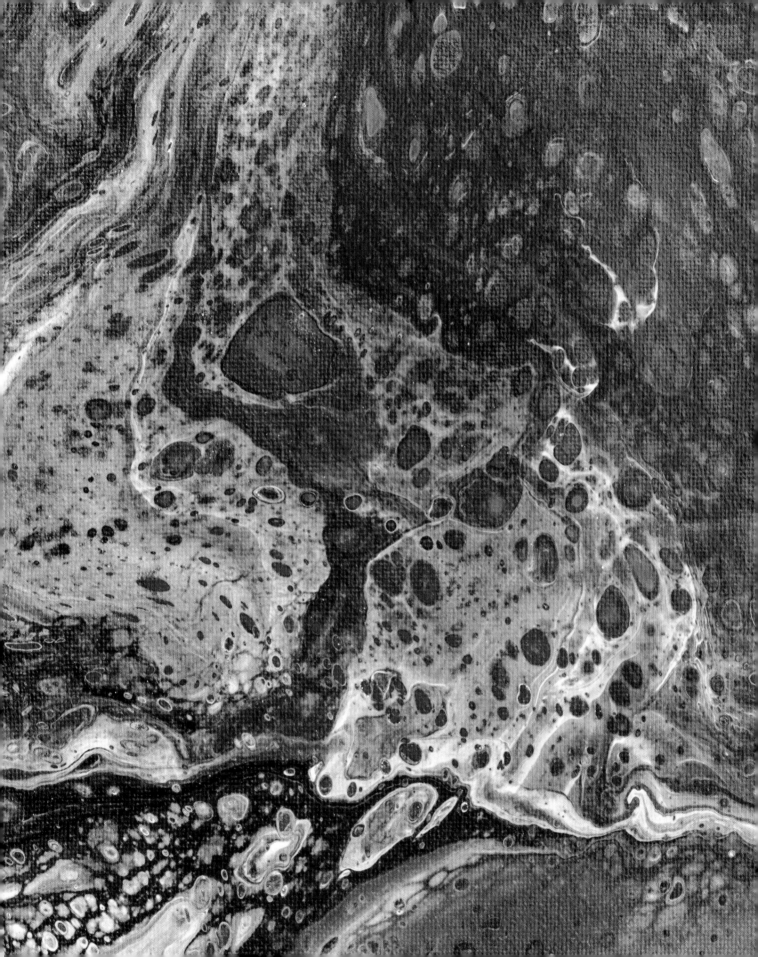

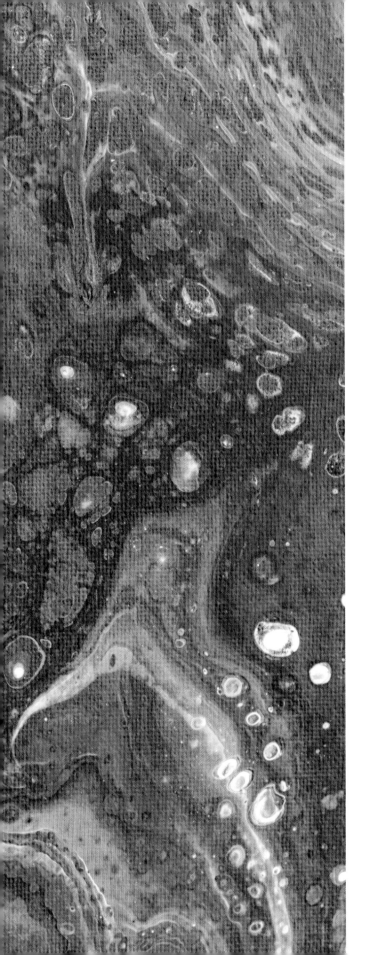

FLIP CUP

The Flip Cup is one of the most popular and all-time favorites for acrylic pourers of all skill levels. It is a simple example of a dirty pour, which describes any pour in which you put all the colors together in a cup before pouring them onto the canvas. All you have to do here is layer your colors in your cup, and then just flip it!

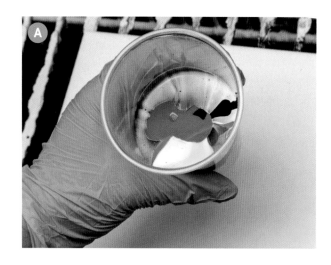

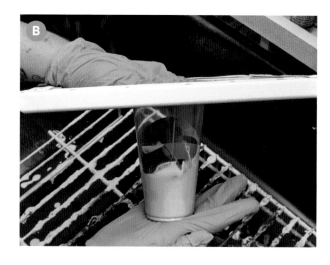

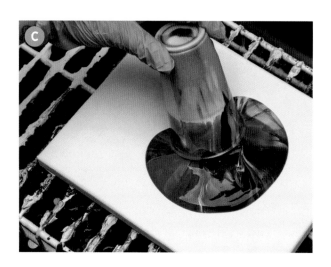

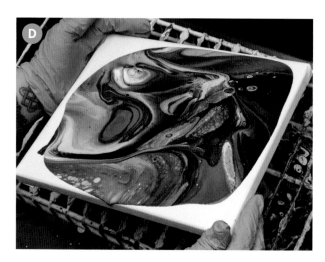

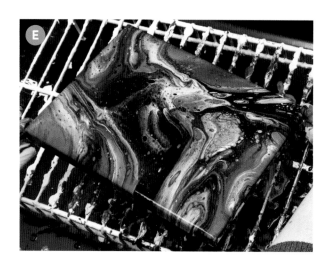

Paint Pouring Tool Kit (page 9)

Acrylic paints, 5 colors of your choice

Pouring medium of your choice

Silicone and other paint additives of your choice (optional)

Canvas

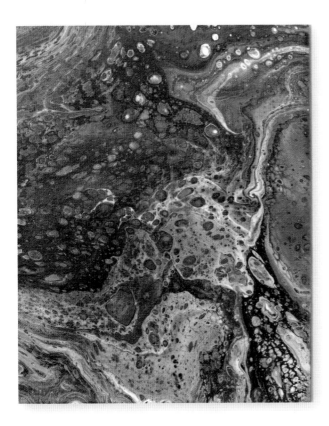

Colors used:
red, orange, yellow, black, white

INSTRUCTIONS

1. With the instructions and recipes on pages 13–15, combine your paints with your chosen pouring medium and paint additives, mixing each color in a separate cup. Layer the paints into another cup, keeping in mind that the first color you pour into the bottom of the cup will become the color on the top of the cup when you flip it **(A)**. I recommend that you use white as your first color for the best cell production.

2. Place the canvas facedown on top of your cup, keeping the cup in the center of your canvas **(B)**. Holding the back of the canvas so that the opening of the cup is sealed, flip the canvas and cup back over so that the cup is upside down on the canvas.

3. Let the cup sit on the canvas for approximately 1 minute, until the paint has settled. Lift the cup off the canvas, letting the paint pour out **(C)**.

4. Tilt the canvas in various directions until it is completely covered with paint **(D)**.

5. Once complete, set the painting on a level drying area **(E)**. Let the paint dry for at least a week, clean off any silicone, if needed, and seal it (see Finishing Your Painting, page 17).

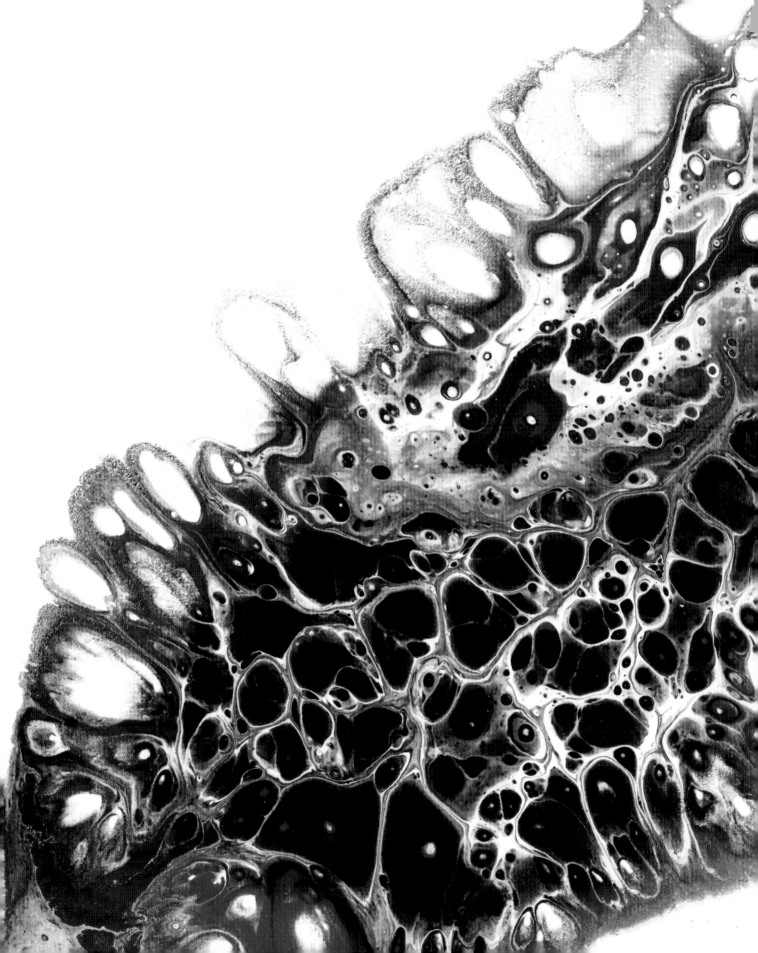

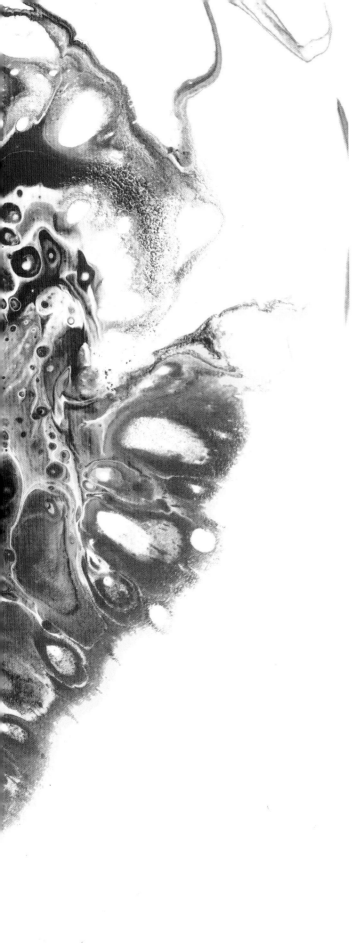

FLIP & DRAG

The Flip and Drag technique combines the Flip Cup (page 27) and Negative Space Pour (page 35). As the name suggests, you will flip your cup of paint and then drag it across a coat of wet paint until the cup is empty. Dragging your cup over wet paint makes it easier to move it across the canvas, and the wet paint creates the negative space in your finished piece.

WHAT YOU NEED

Paint Pouring Tool Kit (page 9)

Acrylic paints, 3 to 5 colors of your choice

Pouring medium of your choice

Silicone and other paint additives of your choice (optional)

1 plastic cup, 2 ounces (60 ml) or smaller, depending on your canvas size

Needle or pin

Tape (any type of tape that is easy to remove will work)

Canvas

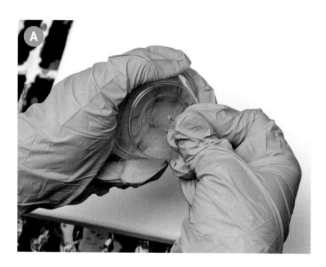

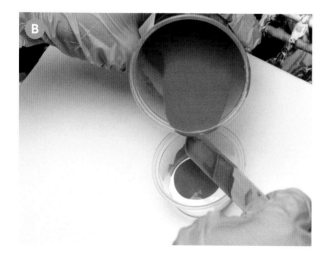

INSTRUCTIONS

1. With the instructions and recipes on pages 13–15, combine your paints with your chosen pouring medium and paint additives, mixing each color in a separate cup. Choose one color for your negative space, ideally white or black, and set that color aside. Poke a hole in the bottom of the 2-ounce (60 ml) cup with a needle or a pin and cover the hole with tape **(A)**. Pour the other paints into the cup **(B)**. Use approximately one-fifth the amount you would normally use on your canvas.

2. Place the canvas facedown on top of the opening of your cup, keeping the cup in a corner of the canvas **(C)**. Then, holding the back of the canvas so that the opening is sealed, flip the cup and canvas over so that the cup is upside down on the canvas **(D)**.

3. Leave the cup turned upside down. Cover your entire canvas with the color you reserved for your negative space **(E)**, using an offset spatula to spread the paint and move it around the cup. Once your canvas is fully covered, take the tape off the bottom of the cup. This will prevent the cup from being suctioned to the canvas. Slowly drag the cup across the canvas until it is empty **(F)**. You don't want to press the cup to the canvas; gently glide it across it, letting out the paint in the cup as you go.

4. Slowly tilt the canvas, leaving as much negative space as you want **(G)**. Once complete, set the painting on a level drying area **(H)**. Let the paint dry for at least a week, clean off any silicone, if needed, and seal it (see Finishing Your Painting, page 17).

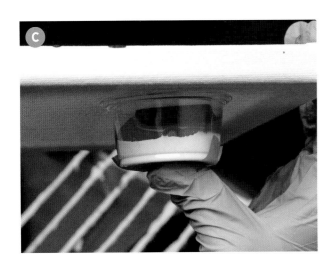

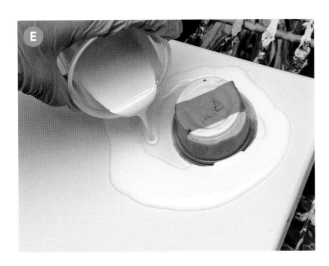

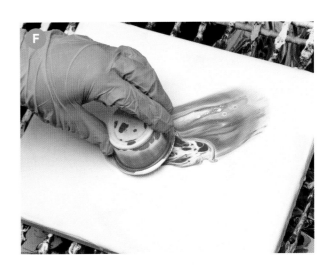

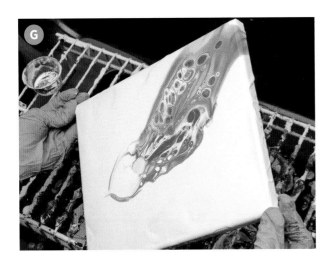

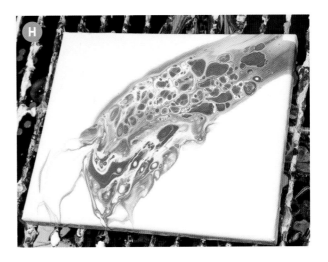

Colors used: white (with silicone), red, yellow, orange

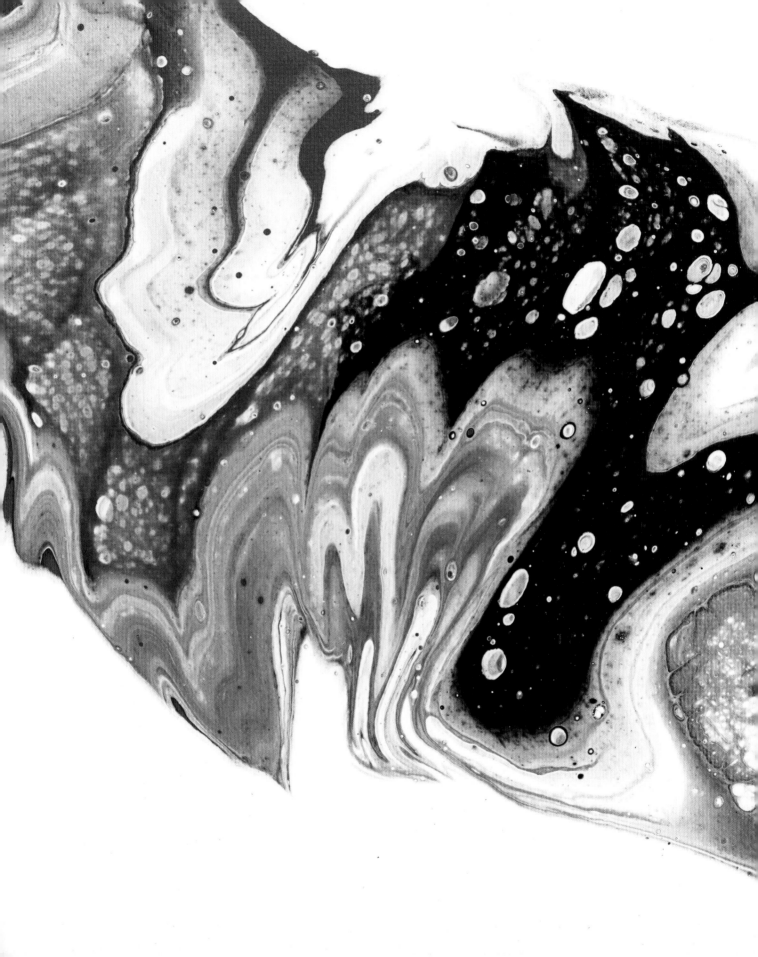

NEGATIVE SPACE POUR

Negative space is the space around, or in between, the main subject of your art. It most often appears as a solid background in a neutral or contrasting color. Using negative space with an acrylic pour can help your pour stand out, especially if you use a contrasting color for the negative space.

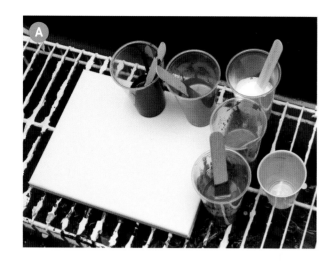

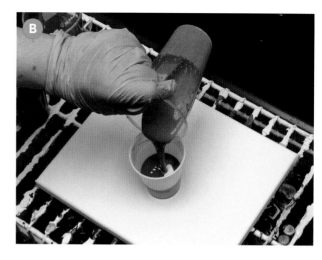

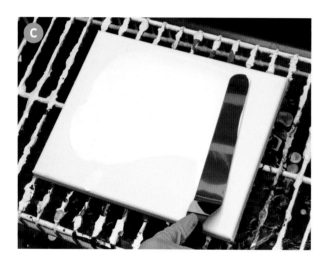

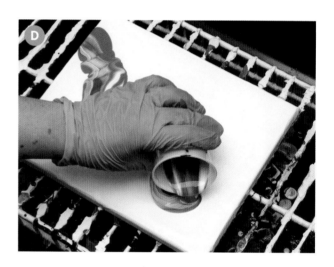

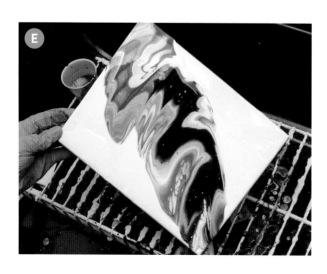

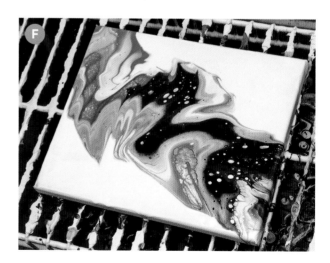

WHAT YOU NEED

Paint Pouring Tool Kit (page 9)

Acrylic paints, 4 or 5 colors of your choice

Pouring medium of your choice

Silicone and other paint additives of your choice (optional)

Canvas

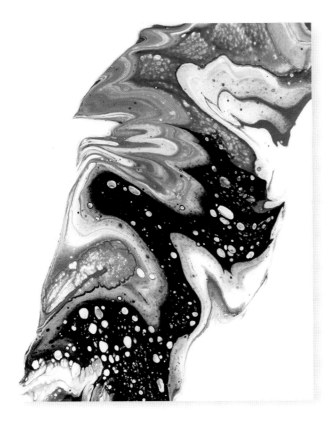

Colors used:
purple, orange, turquoise, white, black

INSTRUCTIONS

1. With the instructions and recipes on pages 13–15, combine your paints with your chosen pouring medium and paint additives, mixing each color in a separate cup **(A)**. Choose a color for your negative space and set it aside; I recommend using black, white (as I did here), or a color that will complement the other colors that you chose. In a separate cup, layer the paints you want to use for your positive space, using approximately half the amount you would normally use for the size of your canvas **(B)**. (You only need half the amount because you will be covering your canvas with the paint that you set aside for the negative space.)

2. Cover your canvas with the paint that you reserved for the negative space. Pour the paint onto the canvas, then move it around with a scraping tool, such as an offset spatula **(C)**, or by tilting.

3. Pour the paint mixture from your other cup in any pattern on the canvas **(D)**.

4. Tilt the canvas to move the paint around **(E)**. Make sure to leave some areas uncovered so you can see the negative space.

5. Once complete, set the painting on a level drying area **(F)**. Let the paint dry for at least a week, clean off any silicone, if needed, and seal it (see Finishing Your Painting, page 17).

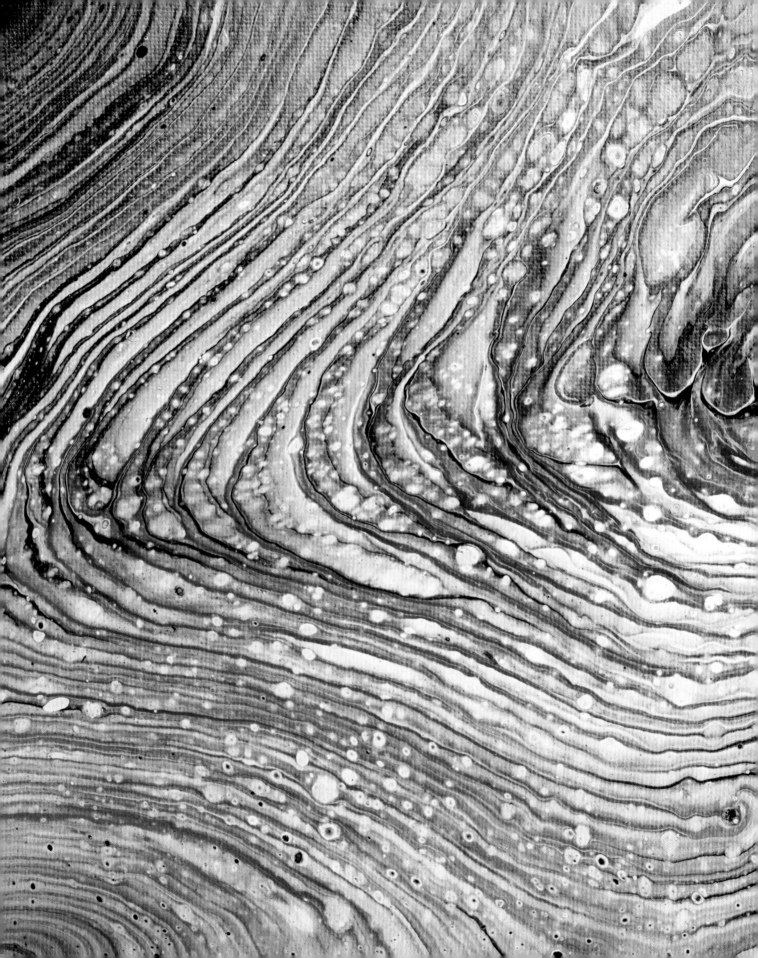

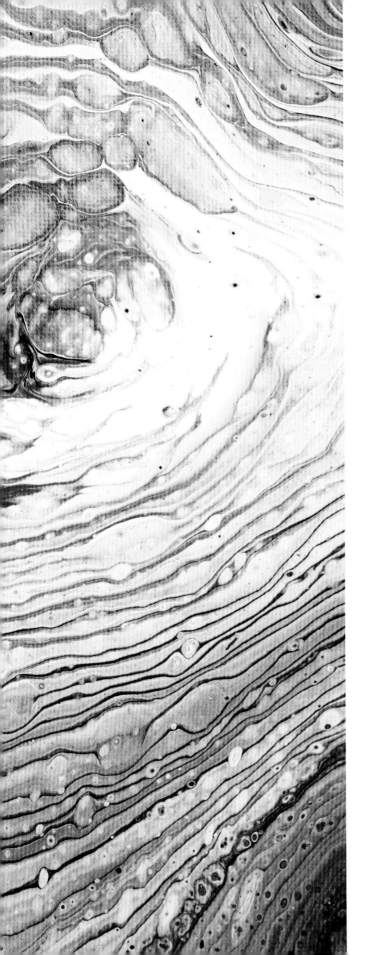

TREE RING POUR

The Tree Ring acrylic pour is my personal favorite. This technique is so much fun, and I love the beautiful swirly designs it creates. It is another dirty pour, in which you layer your paints into a cup and then pour your paint slowly in a circular motion. This can create effects that resemble the rings of a tree, hence the name of this technique.

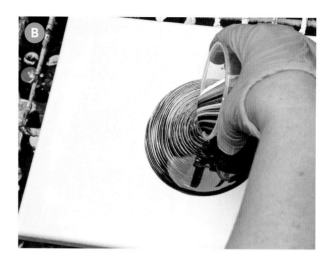

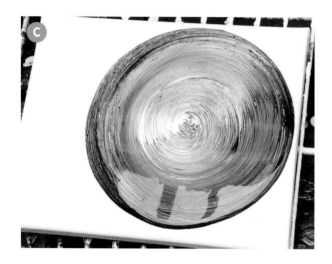

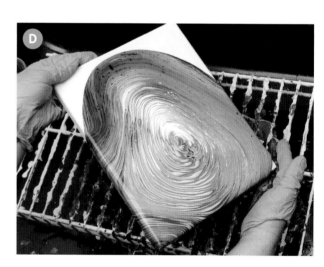

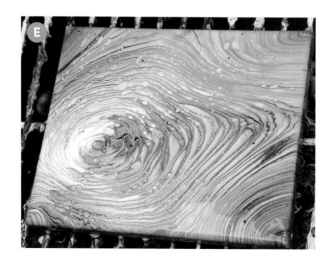

WHAT YOU NEED

Paint Pouring Tool Kit (page 9)

Acrylic paints, 5 colors of your choice

Pouring medium of your choice

Silicone and other paint additives of your choice (optional)

Canvas

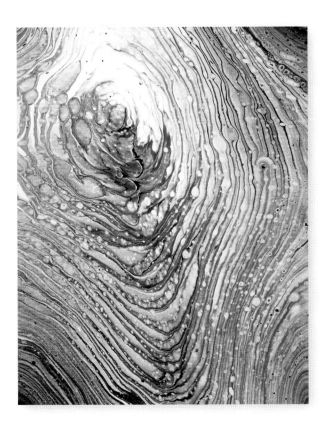

Colors used:
blue, turquoise, purple, white, black

INSTRUCTIONS

1. With the instructions and recipes on pages 13–15, combine your paints with your chosen pouring medium and paint additives, mixing each color in a separate cup. It's better to use many small amounts of several colors than using larger amounts of fewer colors. This will help you create more clearly defined rings and prevent your colors from blending together too much. Add your premixed paints to a new cup in any order that you want (A). Remember that the first color you add to the cup will be the last color that you pour out.

2. Pour paint slowly onto the middle of the canvas, moving in a very slight circular motion, until the entire cup is empty (B, C). The slower you pour, the more clearly defined and evenly shaped your rings will be.

3. Slowly tilt the canvas in a circular motion to cover it with paint. The paint will begin to drip off the sides as you tilt. To cover the corners, tip the canvas toward each corner (D). Remember to move slowly; you do not want too much paint to run off the canvas or you may lose your rings.

4. Once complete, set the painting on a level drying area (E). Let the paint dry for at least a week, clean off any silicone, if needed, and seal it (see Finishing Your Painting, page 17).

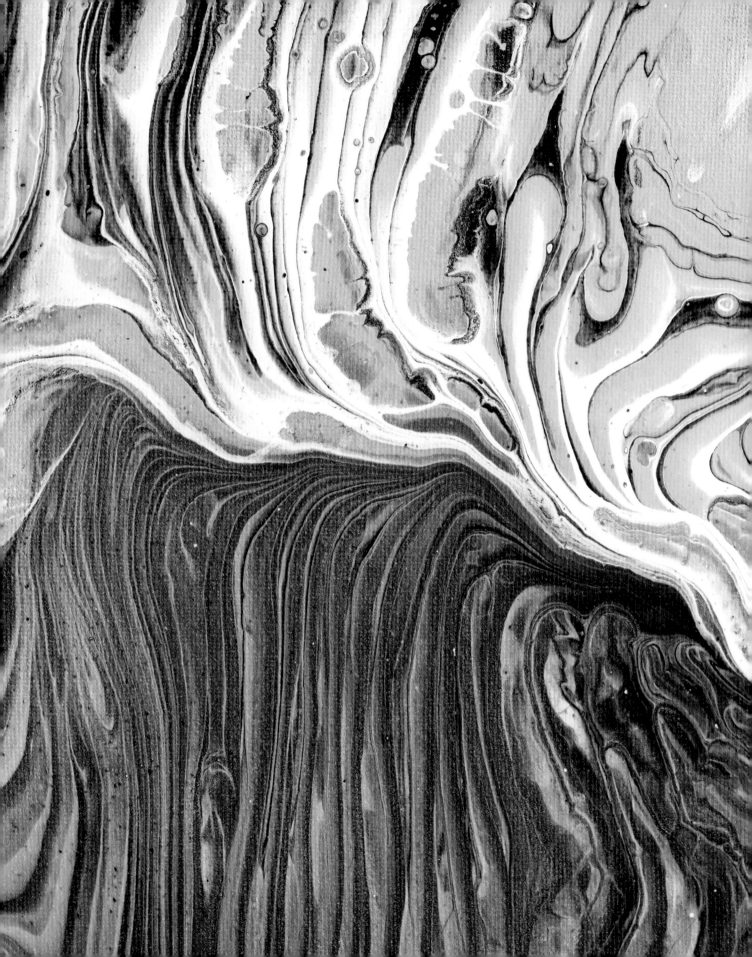

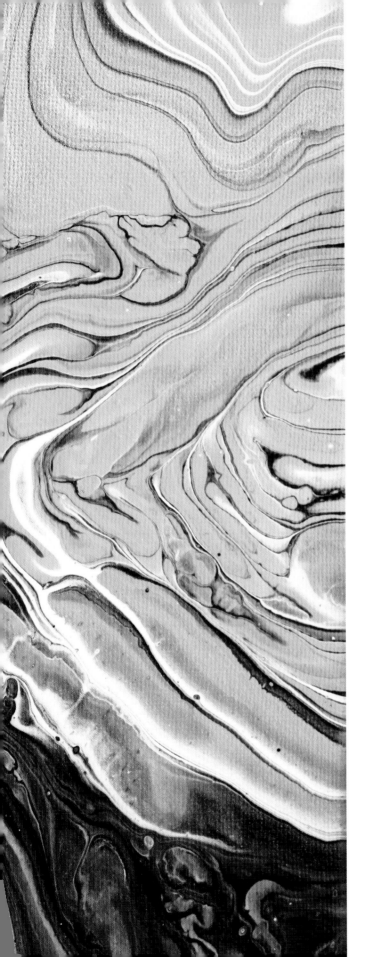

TRAVELING TREE RING POUR

The Traveling Tree Ring is the Tree Ring Pour technique (page 39) with a twist! Instead of just pouring the paint in the middle, you "travel" across the canvas with the tree rings, creating a unique and beautiful pattern.

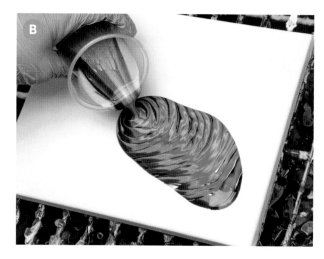

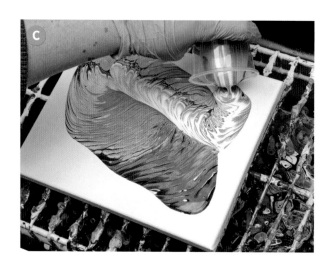

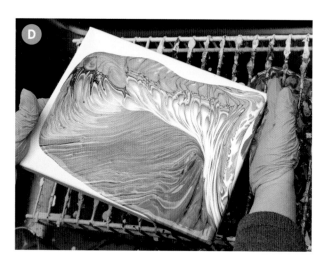

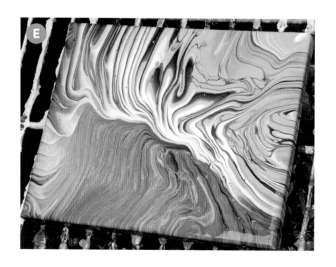

Paint Pouring Tool Kit (page 9)

Acrylic paints, 5 colors of your choice

Pouring medium of your choice

Silicone and other paint additives of your choice (optional)

Canvas

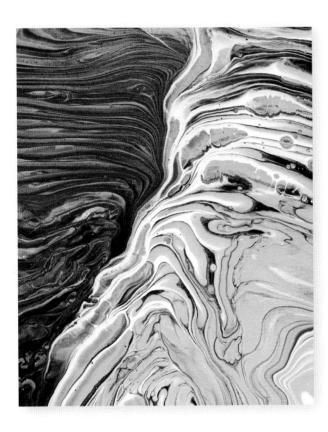

Colors used:
turquoise, gold, orange, white, black

1. With the instructions and recipes on pages 13–15, combine your paints with your chosen pouring medium and paint additives, mixing each color in a separate cup. As with the Tree Ring Pour, it's better to use small amounts of several colors than large amounts of fewer colors. Add your premixed paints to a new cup in any order that you want **(A)**. Remember that the first color you add to the cup will be the last color that you pour out.

2. Starting in one corner of the canvas, pour the paint slowly using a very slight circular motion **(B, C)**. Move across the canvas, pouring the paint in this fashion until the entire cup is empty.

3. Slowly tilt the canvas in a circular motion to cover the entire canvas with paint. The paint will begin to drip off the sides as you tilt. To cover the corners, tip the canvas toward each corner **(D)**. Remember to move slowly; you do not want too much paint to run off the canvas or you may lose your design.

4. Once complete, set the painting on a level drying area **(E)**. Let the paint dry for at least a week, clean off any silicone, if needed, and seal it (see Finishing Your Painting, page 17).

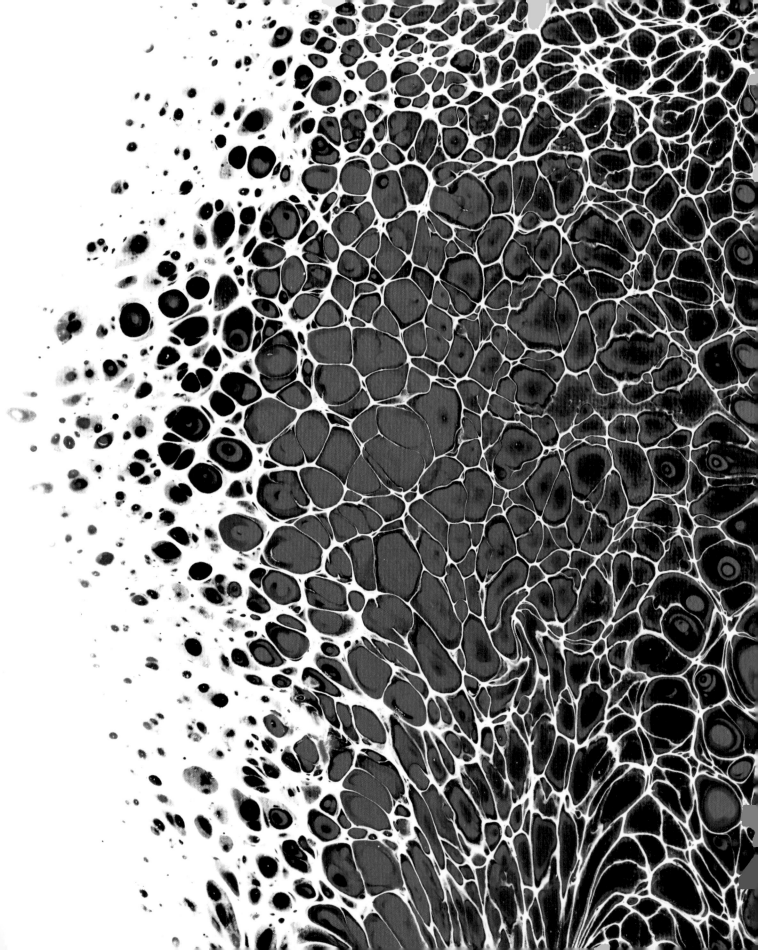

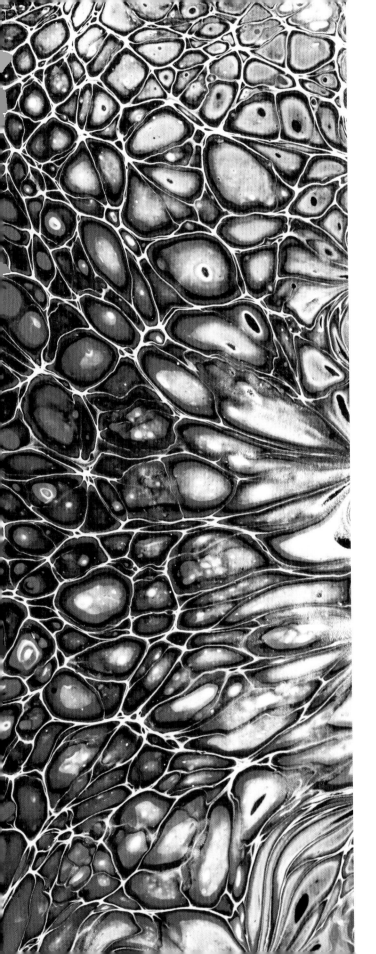

SWIPING

Swiping is a fun technique that can take a little practice. You can use many tools to swipe, including cardboard, a squeegee, a paper towel, and more. Whenever I feel like doing a swipe, I just grab whatever is around, usually cardboard or card stock, but I've even tried it with a comb! The key to this technique is to use a light touch and to brush across the paint without taking it off the canvas. This technique works best with silicone or an additional additive if you want help with creating cells. You can swipe in any direction—vertically, horizontally, diagonally, or any combination of the above.

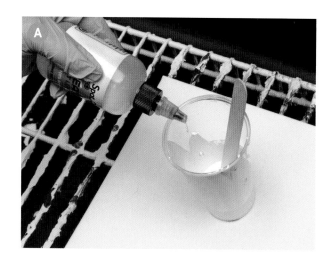

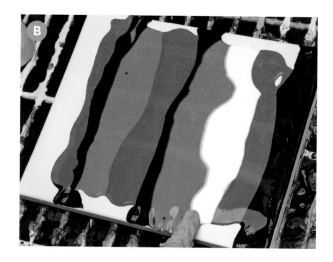

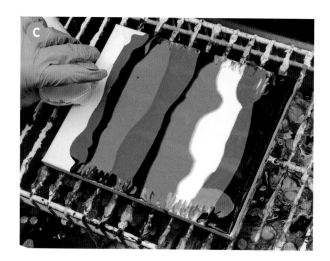

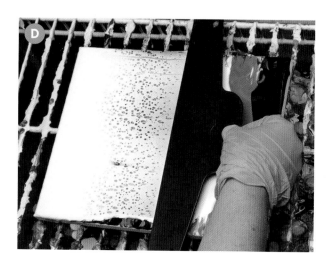

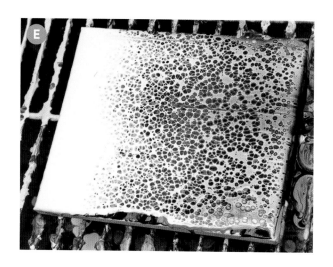

WHAT YOU NEED

Paint Pouring Tool Kit (page 9)

Acrylic paints, 4 or 5 colors of your choice

Pouring medium of your choice

Silicone or oil

Canvas

Swipe tool of your choice (page 9)

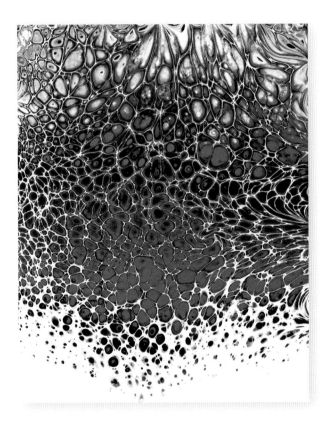

Colors used:
white (with 2 drops of silicone), black, purple, blue

INSTRUCTIONS

1. With the instructions and recipes on pages 13–15, combine your paints with your chosen pouring medium, mixing each color in a separate cup. Pick one color that you would like to use for swiping. (This is generally white or black, but you can select any color.) Mix your chosen color with 2 drops of silicone **(A)**.

2. Pour the remaining colors onto your canvas, one at a time **(B)**. An easy way to do this is to apply the paint in vertical stripes down your canvas. Cover most of your canvas, leaving a small strip of the canvas empty at one end. You can use your fingers to help push the paint to the edges of the canvas to cover any empty areas.

3. Cover the empty strip with the color with which you would like to swipe **(C)**. Using a swipe tool, such as the plastic paint guide shown in the photo, very gently pull the paint across the canvas **(D)**. Do not press all the way down into the canvas as you will simply scrape the paint off. You want to lightly glide your swipe tool in the paint without touching the canvas. This can take some practice!

4. Once complete, set the painting on a level drying area **(E)**. Let the paint dry for at least a week, clean off any silicone, and seal it (see Finishing Your Painting, page 17).

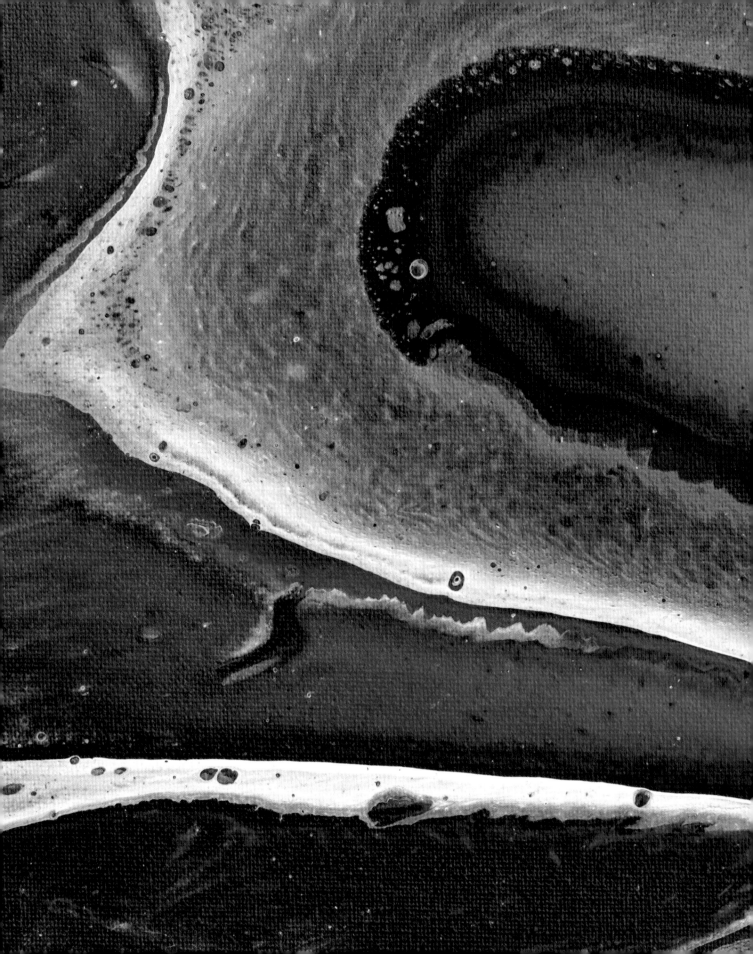

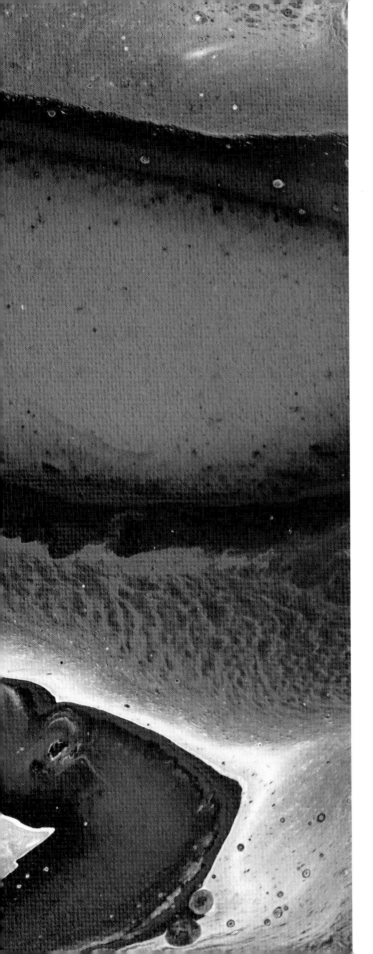

PUDDLE POUR

This technique consists of a clean pour that uses a series of puddles to create layers of color. You can pour your paints into one big puddle, or pour a series of smaller puddles across your canvas.

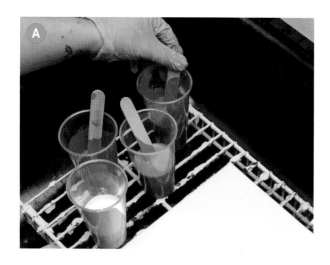

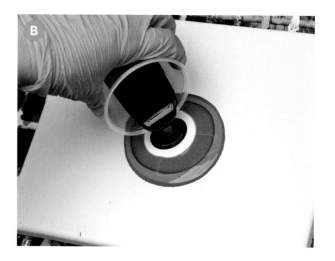

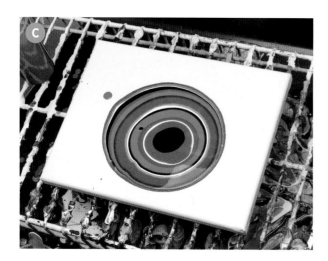

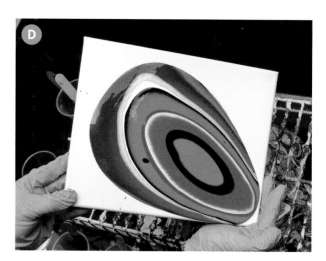

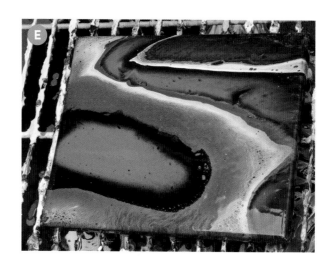

WHAT YOU NEED

Paint Pouring Tool Kit (page 9)

Acrylic paints, 4 or 5 colors of your choice

Pouring medium of your choice

Silicone and other paint additives of your choice (optional)

Canvas

Colors used:
black, purple, blue, red, white

INSTRUCTIONS

1. With the instructions and recipes on pages 13–15, combine your paints with your chosen pouring medium and paint additives, mixing each color in a separate cup **(A)**. For this technique, you can choose as many colors as you'd like, though I recommend sticking to four or five to keep it simple.

2. Pour a small circle of your first color on the canvas. This creates your first puddle. Pour the next color directly into that circle. Repeat with the remaining paints, until you have added the correct amount of paint that you need for the size of your canvas **(B, C)**. You can add the paint in a particular order or at random. You can create as many puddles as you want, but whether you're making one large puddle with your paint or a series of smaller puddles, make sure you're using small amounts of each color, about a quarter of an ounce (7 ml).

3. Slowly tilt the canvas toward each corner until the entire surface is covered **(D)**, running the paint off the sides in all directions.

4. Once complete, set the painting on a level drying area **(E)**. Let the paint dry for at least a week, clean off any silicone, if needed, and seal it (see Finishing Your Painting, page 17).

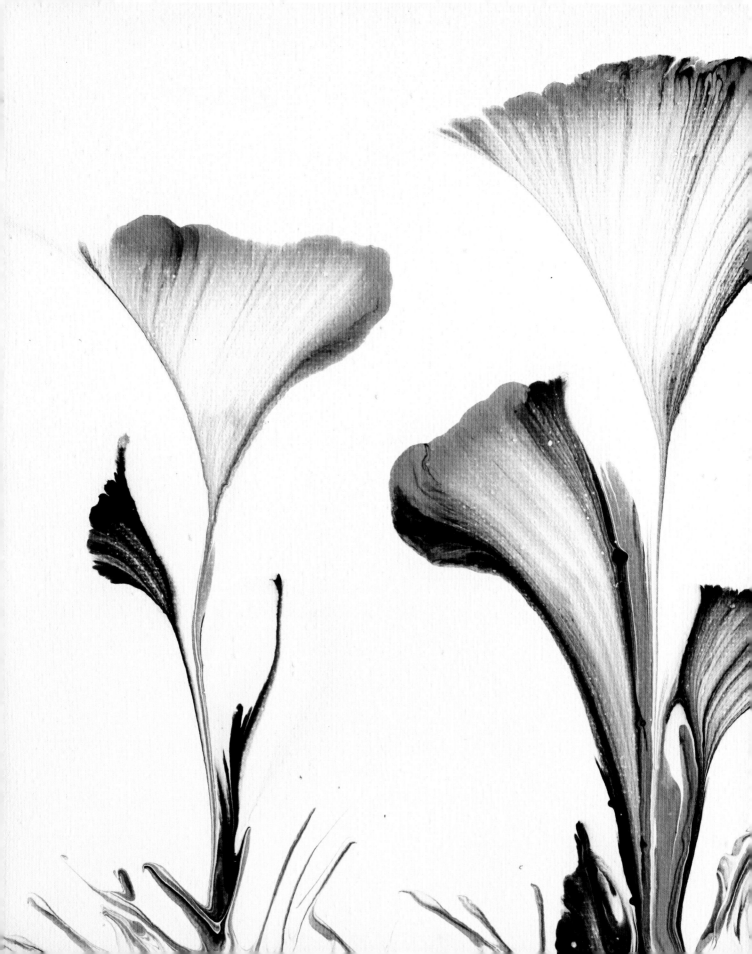

STRING PULL

The String Pull utilizes a paint-covered string to create interesting designs, such as a feather or flower shape. You can use a variety of items besides cotton string, including chains, ribbon, and yarn. Each will give you a different result, so I recommend trying this technique out with several different items. Avoid using something too thin, such as thread, as it won't hold the design of the string pull.

WHAT YOU NEED

Paint Pouring Tool Kit (page 9)

Acrylic paints, 2 or more colors of your choice

Pouring medium of your choice

Silicone and other paint additives of your choice (optional)

Plate or other container for dipping your string

Canvas

Cotton string or string made from material of your choice

Scissors

INSTRUCTIONS

1. With the instructions and recipes on pages 13–15, combine your paints with your chosen pouring medium and paint additives, mixing each color in a separate cup. Choose a color for your negative space and contrasting colors for your string pull. You need just a small amount of paint for your string pull (about ½ fluid ounce/15 ml will be enough). Pour the colors for your string pull onto the plate and set it aside **(A)**.

2. Start by pouring your negative space paint color directly onto your canvas. Spread it around with an offset spatula or by tilting the canvas until you have a very thin layer of paint covering the entire canvas **(B)**.

 NOTE: *It is very important that the first layer of paint is thin in order for this technique to work properly. You can also create the base with a dirty pour—just make sure you don't use too much paint.*

3. Cut a piece of string that is at least 2 inches (5.1 cm) longer than the length of your canvas. Err on the side of having a piece that is too long rather than too short.

4. Dip the string in a contrasting color. For example, if your base color is black, use white or another color that will stand out as opposed to using a dark color. You can dip your string in more than one color, if desired **(C)**. If needed, use a stirring stick to cover the string fully.

5. Zigzag the string across the canvas, leaving one end running off a side of the canvas **(D)**. Slowly pull the string straight toward you without lifting it up from the canvas, until you have pulled the entire string off **(E)**. You will see a feather- or flowerlike design appear. Repeat as many times as desired, reapplying paint to your string as needed **(F)**.

6. Once complete, set the painting on a level drying area **(G)**. Let the paint dry for at least a week, clean off any silicone, if needed, and seal it (see Finishing Your Painting, page 17).

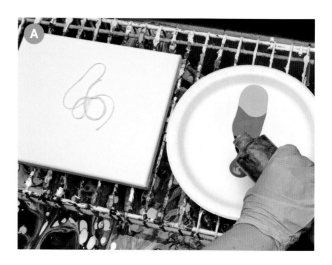

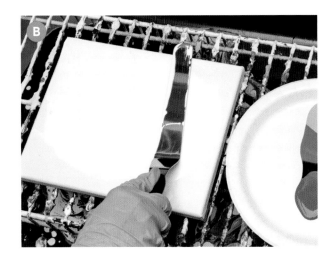

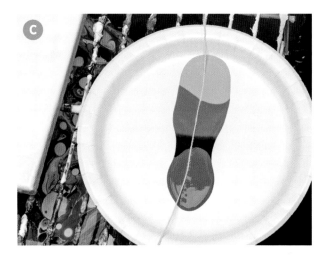

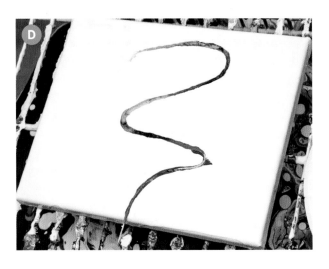

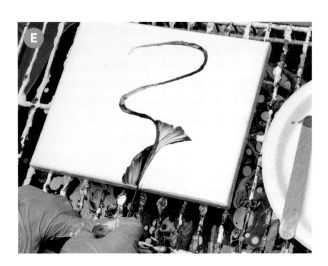

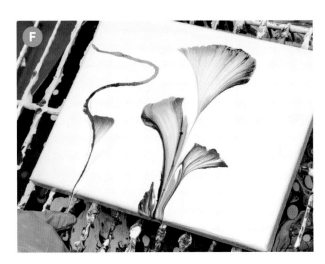

Colors used: white, black, blue, turquoise, pink

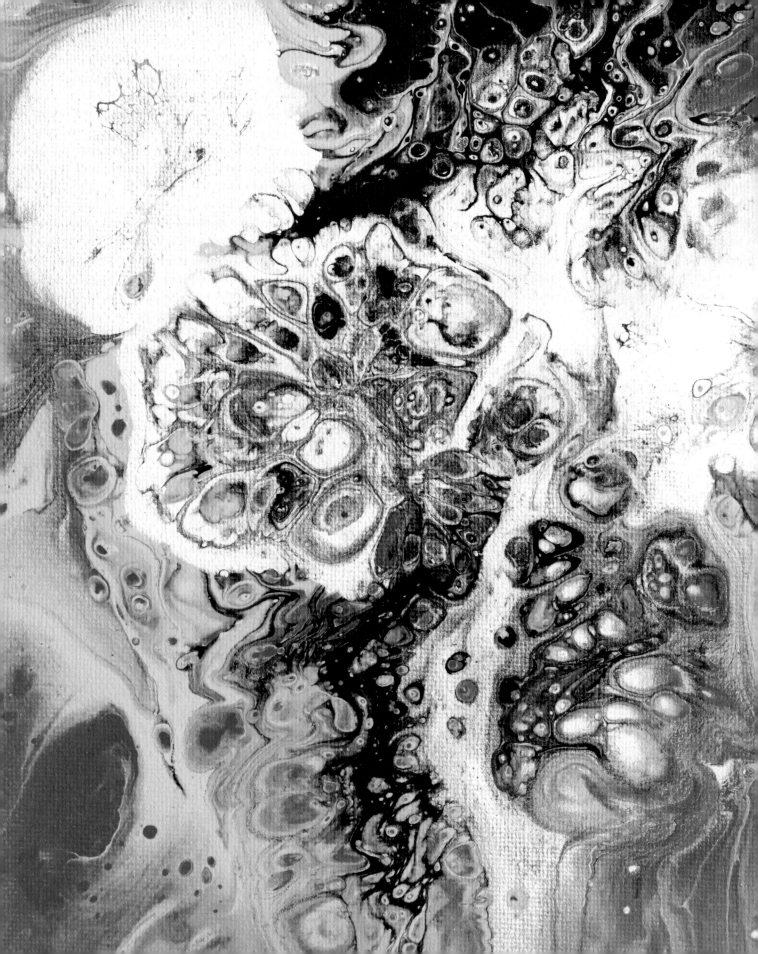

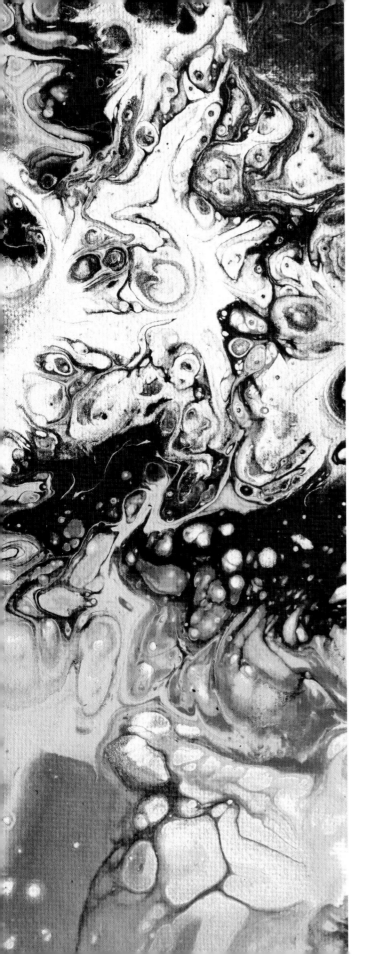

HAMMER SMASH

With this fun technique, you will use a hammer or a mallet to "smash" your design. This works well on a hard surface, such as wood, but you can also use canvas or paper and simply place something firm and sturdy underneath. The force of the hammer pushes the paints against and through each other, creating some fun cells and designs.

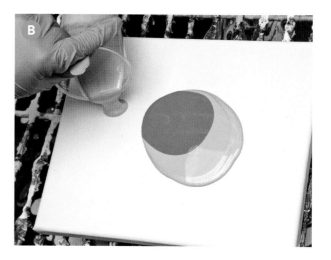

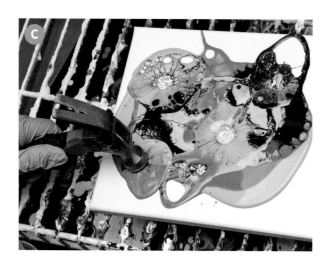

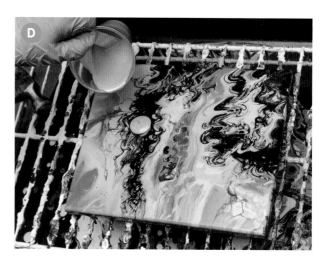

Paint Pouring Tool Kit (page 9)

Acrylic paints, 4 or 5 colors of your choice

Pouring medium of your choice

Silicone and other paint additives of your choice (optional)

Canvas

A heavy item to place under canvas, such as a book or wood block

Hammer or mallet

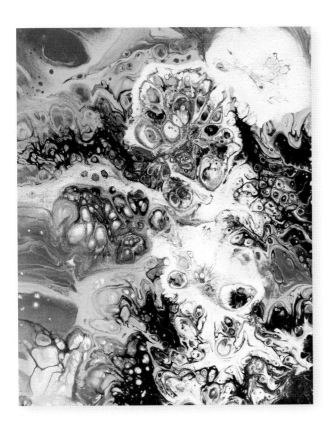

Colors used:
silver, turquoise, blue, black (with 2 drops of silicone)

1. With the instructions and recipes on pages 13–15, combine your paints with your chosen pouring medium and paint additives, mixing each color in a separate cup.

2. Place your canvas on top of the heavy item **(A)**. This technique may cause some paint splatters, so it is wise to put the canvas setup in a bin or a box to contain any flying paint droplets.

3. Cover your canvas completely with a solid base color. Pour the paint onto the canvas, then move it around with a scraping tool, such as an offset spatula, or by tilting. Pour additional colors onto your canvas in as many small puddles as you would like, layering two or three colors in each puddle **(B)**.

4. Gently strike your canvas with the hammer to spread and mix the colors **(C)**. Hit each puddle individually to splatter and spread the paint as you desire. Continue in this fashion until you are happy with your design. Feel free to also tilt your canvas or add more paint in puddles in between hammer hits **(D)**.

 TIP: *Cover the hammer with plastic wrap beforehand to keep it clean, or simply wipe it off with a paper towel or cloth immediately after use.*

5. Once complete, set the painting on a level drying area. Let the paint dry for at least a week, clean off any silicone, if needed, and seal it (see Finishing Your Painting, page 17).

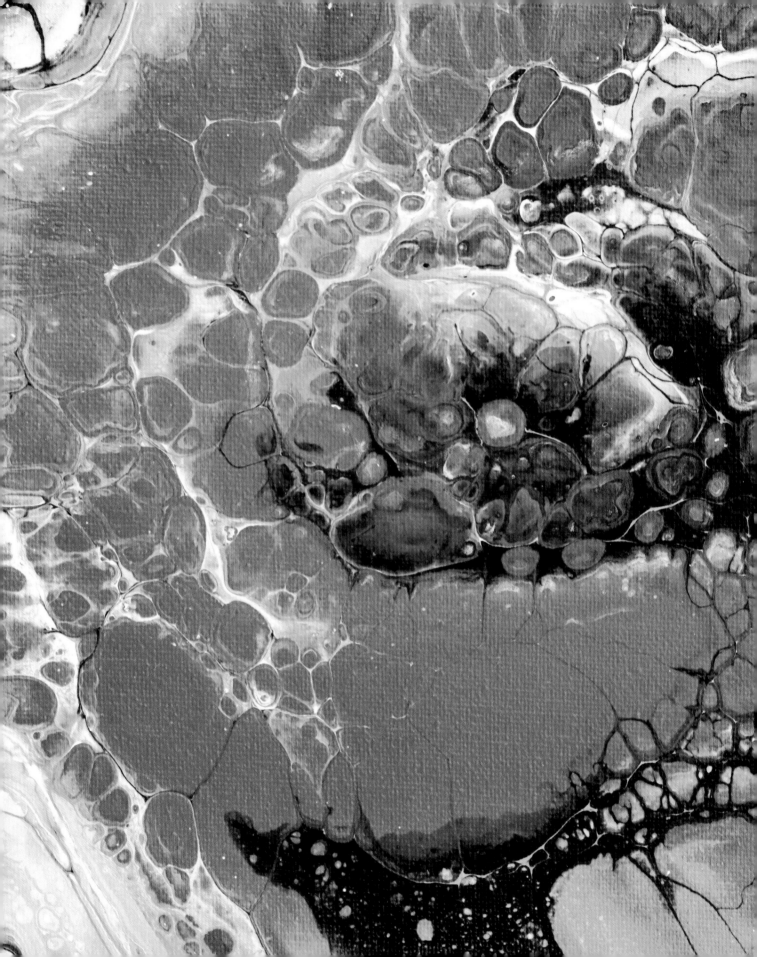

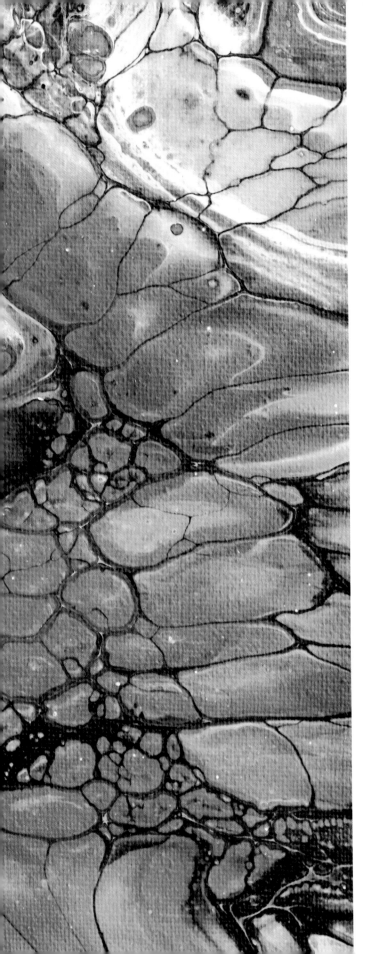

FUNNEL POUR

A funnel allows you to control and apply the paint differently than other methods. Using the small end of the funnel, you can slowly let the paint out onto your canvas in a controlled fashion. This technique creates effects similar to those of Flip and Drag (page 31), in which you apply your paints underneath a layer of a solid color, causing all the hues to react against each other and create cells and interesting patterns.

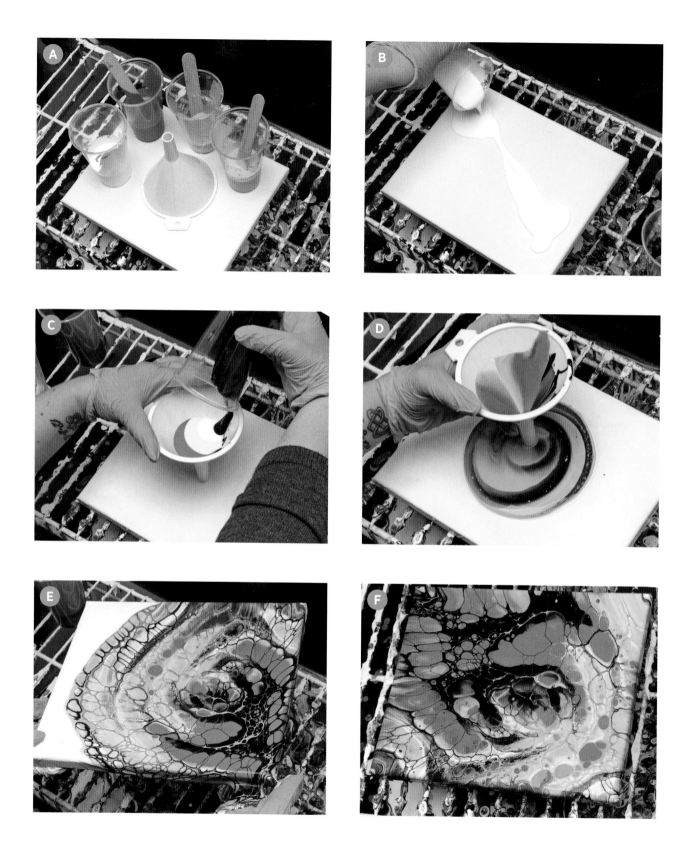

Paint Pouring Tool Kit (page 9)

Acrylic paints, 4 or 5 colors of your choice

Pouring medium of your choice

Silicone and other paint additives of your choice (optional)

Canvas

Funnel

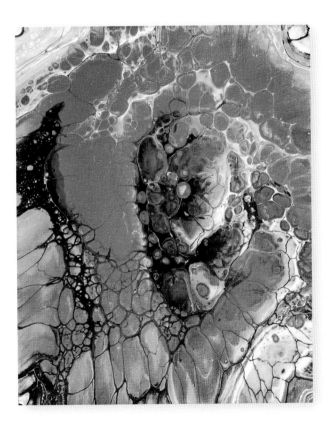

Colors used:
white, green, black (with 2 drops of silicone), blue, yellow

1. With the instructions and recipes on pages 13–15, combine your paints with your chosen pouring medium and paint additives, mixing each color in a separate cup **(A)**.

2. Cover the canvas evenly with a solid color, such as white or black. Pour the paint onto the canvas **(B)**, then move it around with a scraping tool, such as an offset spatula, or by tilting.

3. Place the funnel on your canvas wherever you want. Press the bottom of the funnel directly against the canvas so that it is blocked off. Fill the funnel in the order you'd like with enough paint to cover the canvas using the guidelines outlined on page 14 **(C)**.

4. Slowly lift the funnel just above the canvas, but leave the opening submerged in the base color. Move the funnel around the canvas in a circular pattern until all the paint has flowed out. This will allow you to release the paint beneath the base coat of paint **(D)**.

5. Tilt the canvas as desired, running the paint off the canvas in all directions until you are satisfied with your design **(E)**.

6. Once complete, set the painting on a level drying area **(F)**. Let the paint dry for at least a week, clean off any silicone, if needed, and seal it (see Finishing Your Painting, page 17).

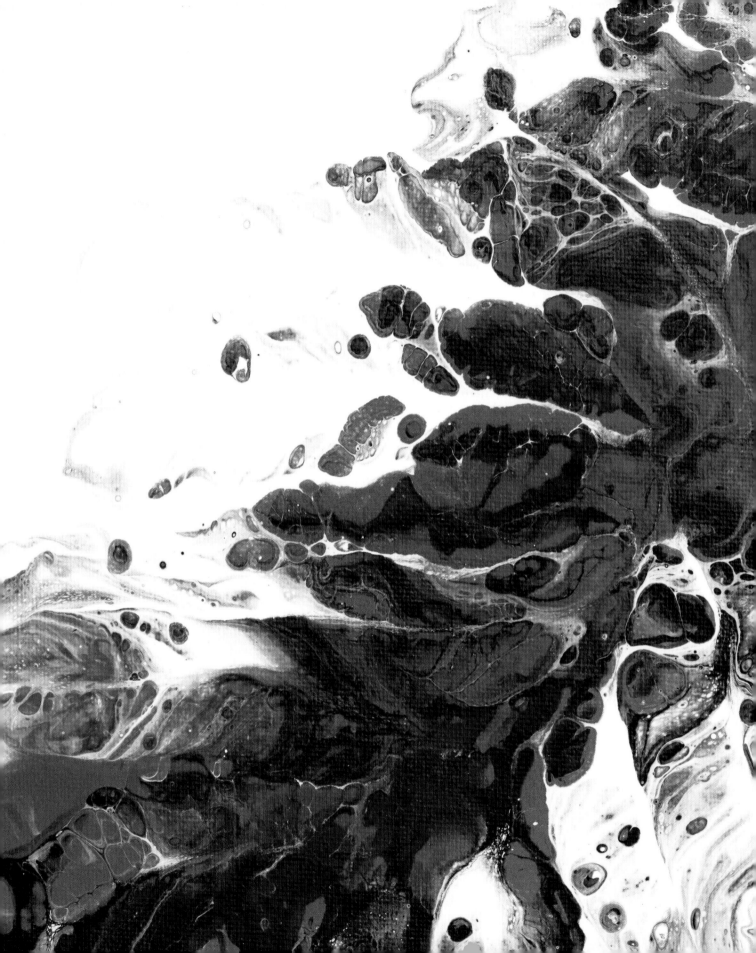

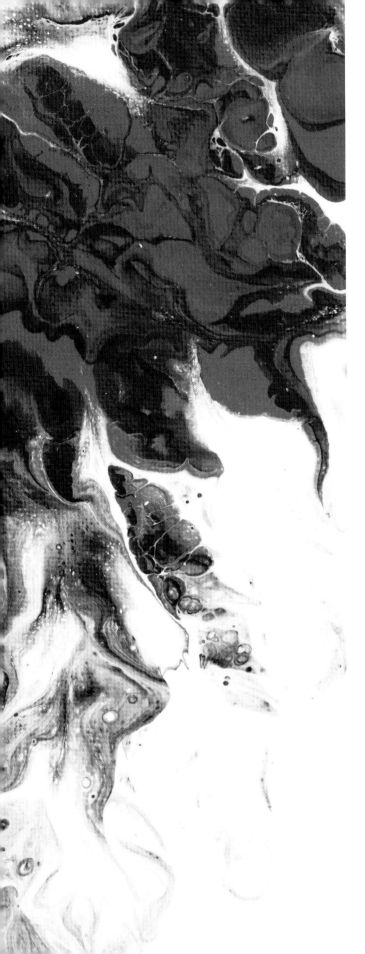

BLOWING

With this technique, you'll blow air to move the paint around, which can help create cells and fun designs! You can simply blow on the paint, or control the air with a drinking straw. Machines, such as an air compressor or airbrush, can give you the same effect, but those items might be slightly more difficult to control.

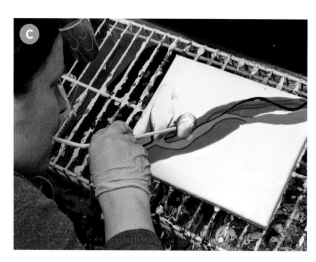

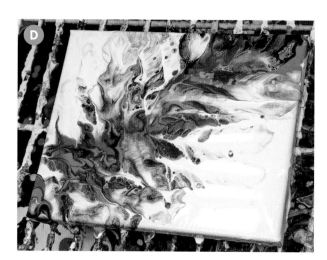

WHAT YOU NEED

Paint Pouring Tool Kit (page 9)

Acrylic paints, 4 or 5 colors of your choice

Pouring medium of your choice

Silicone and other paint additives of your choice (optional)

Canvas

Drinking straw

Colors used:
red, purple, blue, black, white

INSTRUCTIONS

1. With the instructions and recipes on pages 13–15, combine your paints with your chosen pouring medium and paint additives, mixing each color in a separate cup.

2. Cover your canvas completely with a solid base color, such as black or white. Pour the paint onto the canvas, then move it around with a scraping tool, such as an offset spatula, or by tilting **(A)**.

3. Apply additional colors in diagonal stripes across your canvas or in another pattern, such as puddles **(B)**. As you already have a base coat, you only need to apply about half the amount of paint needed for your size canvas, but there is no set rule; you can apply more or less paint if you wish. I recommend leaving plenty of negative space.

4. Using your straw, blow your paint into the solid base color. You can blow the paint around in any direction and create different patterns in the paint as you move it around. Continue in this fashion until you are happy with your design **(C)**. Tilting is not required for this technique, but you certainly can do it if you'd like.

5. Once complete, set the painting on a level drying area **(D)**. Let the paint dry for at least a week, clean off any silicone, if needed, and seal it (see Finishing Your Painting, page 17).

HAIR DRYER POUR

This variation of the Blowing technique (page 67) uses a hair dryer to push the paint in different directions and mix the paints together to create cells and other effects like lacing (a paint design that looks like lace). You can also use hair-dryer attachments that blow the paint in a more controlled fashion. The hair dryer should be used minimally, or the paint can mix too much and become muddy in color.

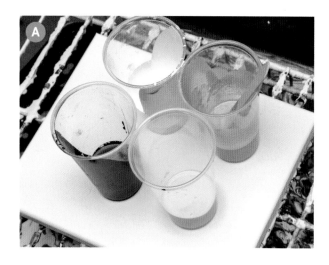

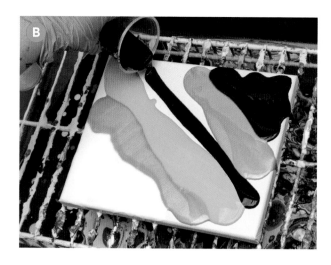

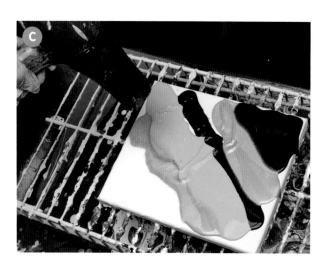

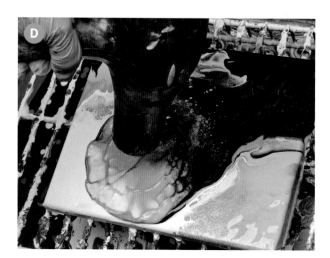

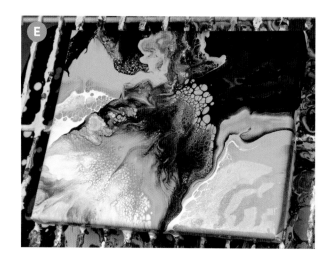

WHAT YOU NEED

Paint Pouring Tool Kit (page 9)

Acrylic paints, 3 to 5 colors of your choice

Pouring medium of your choice

Silicone and other paint additives of your choice (optional)

Canvas

Hair dryer

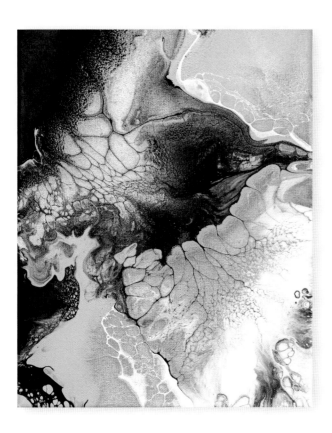

Colors used:
gold, turquoise, black, white

INSTRUCTIONS

1. With the instructions and recipes on pages 13–15, combine your paints with your chosen pouring medium and paint additives, mixing each color in a separate cup **(A)**.

2. Create stripes in any direction on the canvas using three to five colors **(B)**. I like to keep it simple by using only white, black, and one or two additional colors.

3. Using a hair dryer on high air, with low or no heat, gently move your paint around the canvas, fanning it out in various directions **(C, D)**. Move the colors across and into each other to mix them and create cells and unique patterns.

 NOTE: *Move the paint just a small amount with the hair dryer. Too much movement can cause the paint to mix too much. You may only need to use the hair dryer for a few seconds to get a satisfactory result.*

4. Once complete, set the painting on a level drying area **(E)**. Let the paint dry for at least a week, clean off any silicone, if needed, and seal it (see Finishing Your Painting, page 17).

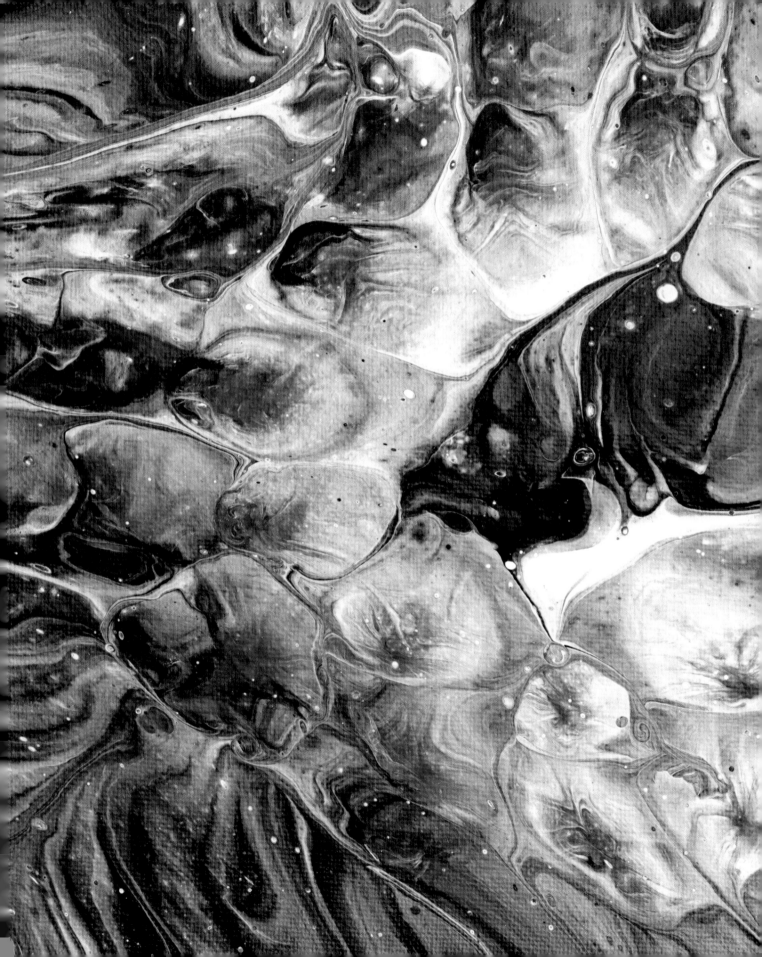

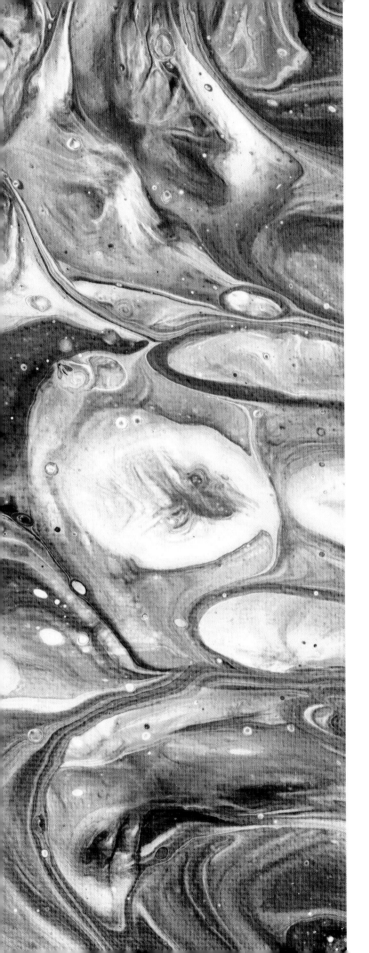

COLANDER POUR

Colanders and strainers are very fun to use in pours. You can use a food strainer, sink strainer, can strainer, mesh strainer, or any other kind you can find. Individual strainers have different holes, shapes, and patterns, so I recommend trying out more than one. This particular technique can be done as a clean pour or dirty pour, as in this example. Once you have used a strainer with paint, do not use it with food and reserve it just for pouring.

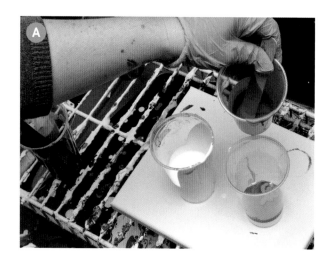

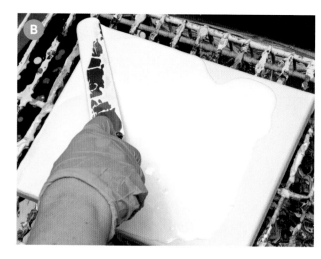

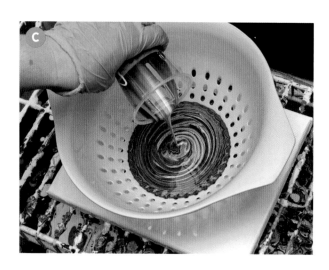

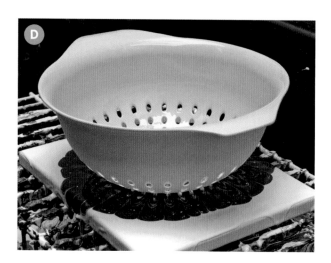

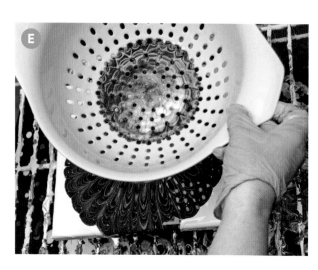

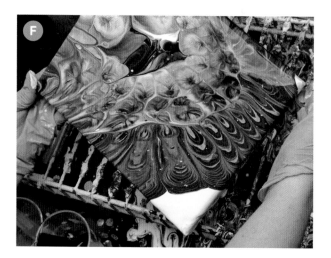

WHAT YOU NEED

Paint Pouring Tool Kit (page 9)

Acrylic paints, 4 or 5 colors of your choice

Pouring medium of your choice

Silicone and other paint additives of your choice (optional)

Canvas

Colander

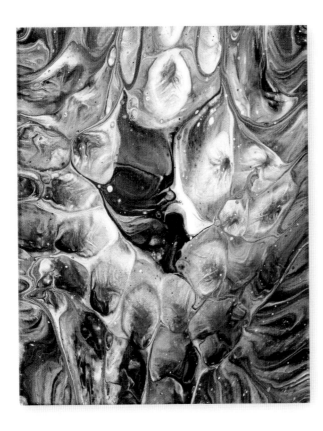

Colors used:
blue, green, red, white, black

INSTRUCTIONS

1. With the instructions and recipes on pages 13–15, combine your paints with your chosen pouring medium and paint additives, mixing each color in a separate cup. You'll only need about three-quarters of the amount that you usually need to cover your canvas. Use as many colors as you like, though I recommend four or five, including black and white. Layer the paints in a new cup in any order you'd like **(A)**. Set the cup aside.

2. Cover your canvas with a solid color, such as white or black **(B)**. Pour the paint onto the canvas, then move it around with a scraping tool, such as an offset spatula, or by tilting.

3. Place the colander in the center of the canvas and pour the paint from the cup into the colander **(C)**. You can pour the paint straight into the colander or in a circular pattern, as shown in the photo.

4. Once you have poured out all of your paint, leave the colander on the canvas for a minute so that the paint can drip through the holes **(D)**, and then carefully move it off of the canvas **(E)**. Slowly tilt your canvas until it is covered, running the paint off of the sides in all directions **(F)**. Feel free to leave some negative space, or cover the entire canvas.

5. Once complete, set the painting on a level drying area. Let the paint dry for at least a week, clean off any silicone, if needed, and seal it (see Finishing Your Painting, page 17).

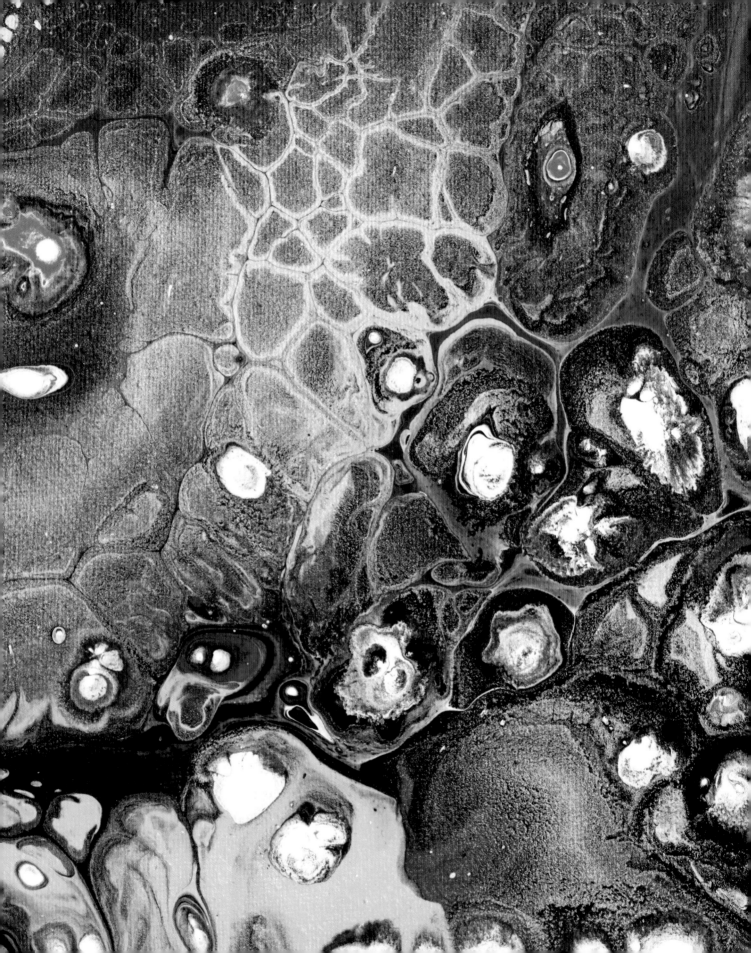

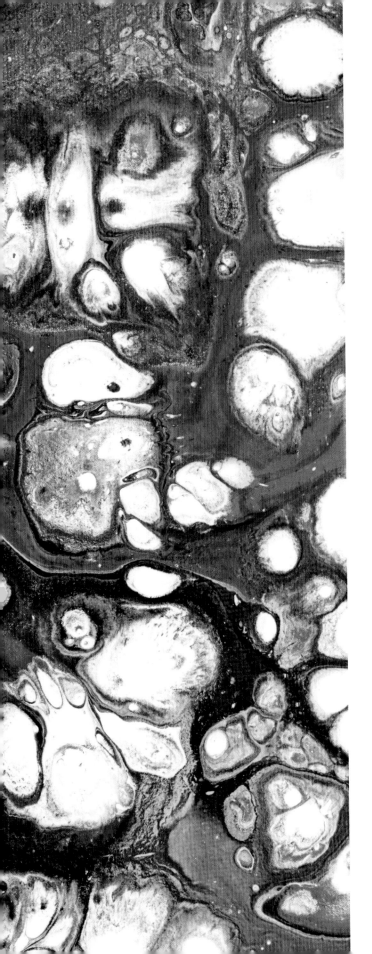

CYLINDER POUR

The Cylinder Pour allows you to do a dirty pour without flipping the cup, and thus without flipping the order of your colors. The order in which you fill the cylinder will also be the order that the paint comes out—this is what makes this fun technique stand out!

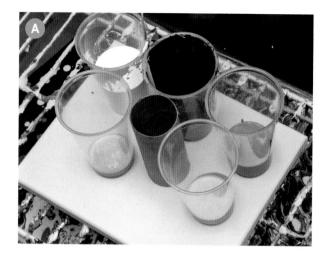

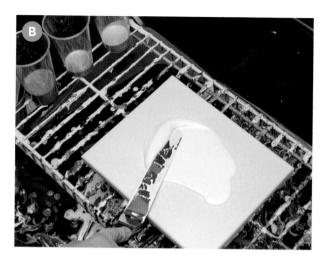

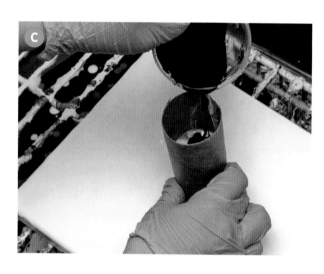

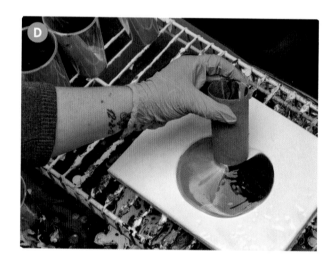

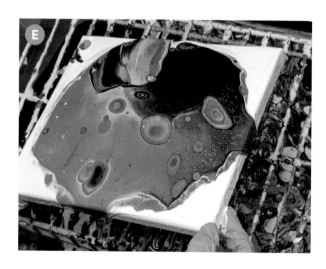

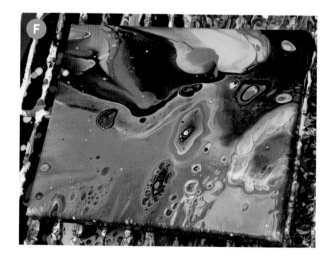

WHAT YOU NEED

Paint Pouring Tool Kit (page 9)

Acrylic paints, 4 or 5 colors of your choice

Pouring medium of your choice

Silicone and other paint additives of your choice (optional)

Canvas

Empty toilet paper roll or short piece of piping, such as PVC

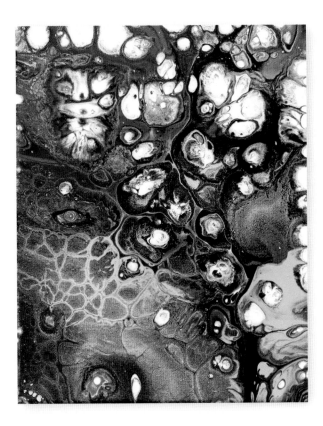

Colors used:
white (with 2 drops of silicone), turquoise, orange, gold, black

INSTRUCTIONS

1. With the instructions and recipes on pages 13–15, combine your paints with your chosen pouring medium and paint additives, mixing each color in a separate cup (A).

2. Cover the canvas evenly with a solid color, such as white. Pour the paint onto the canvas, then move it around with a scraping tool, such as an offset spatula, or by tilting (B).

3. Place the cylinder on your canvas wherever you would like. Make sure the bottom sits directly against the canvas so that it is blocked off. Fill the cylinder with enough paint to cover the canvas using the guidelines outlined on page 14 (C).

4. Slowly lift the cylinder very slightly above the canvas (D) and move it around the canvas in a circular pattern until all the paint has been released.

5. Tilt the canvas as desired, running the paint off the canvas in all directions (E) until you have a design that you are happy with.

6. Once complete, set the painting on a level drying area (F). Let the paint dry for at least a week, clean off any silicone, if needed, and seal it (see Finishing Your Painting, page 17).

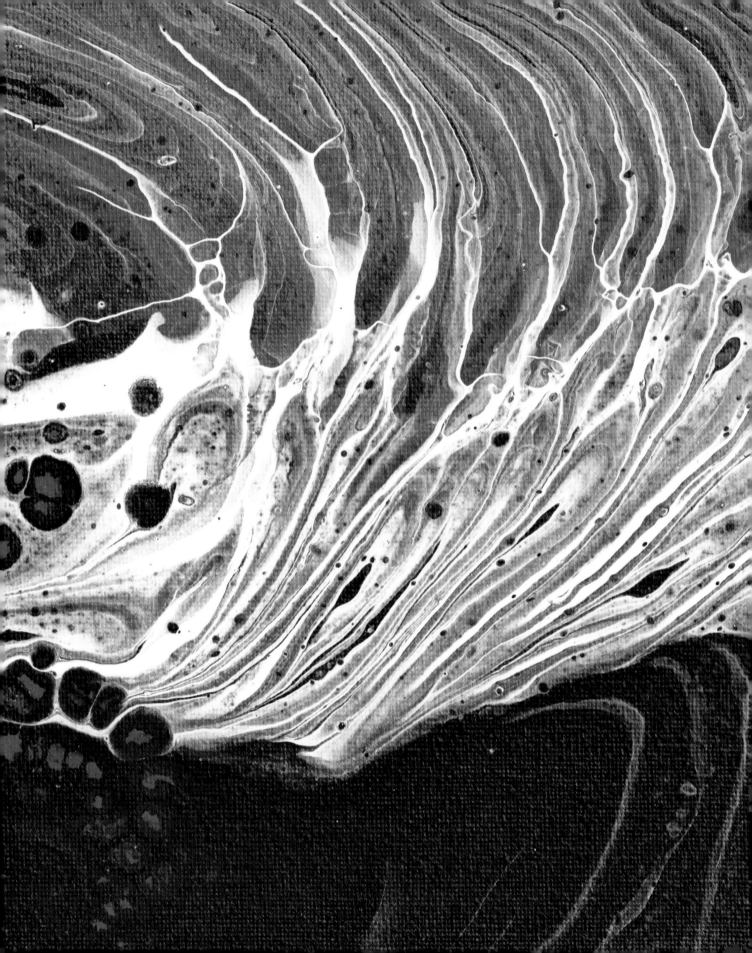

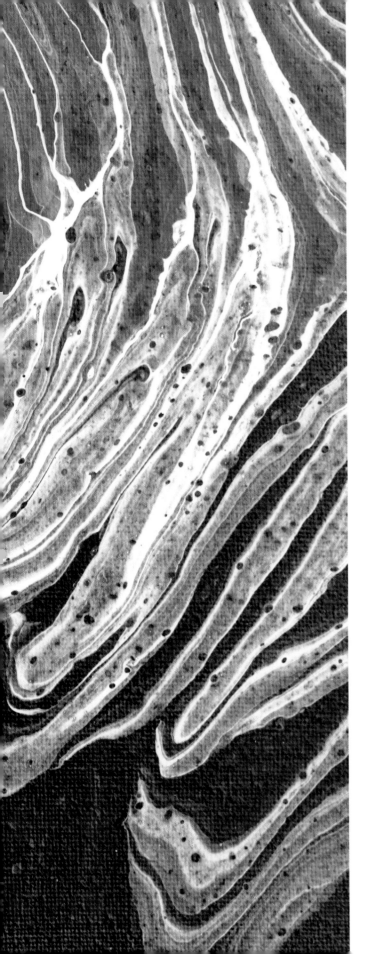

TORNADO POUR

The Tornado Pour is my personal take on the Traveling Tree Ring Pour (page 43). Instead of staying in the middle of the canvas, you travel from one side to the other and then back again. This creates a tornado-looking design in the middle, which you can then manipulate any way you'd like with tilting.

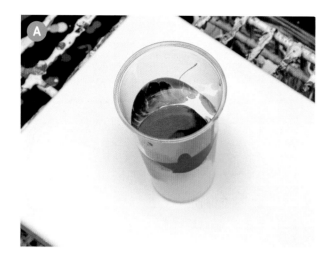

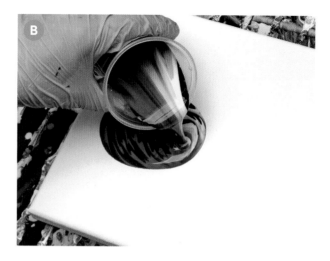

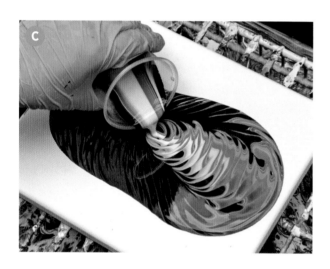

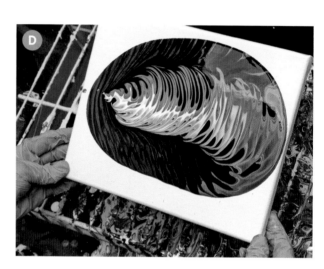

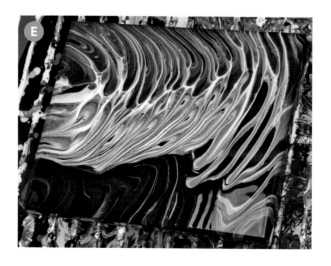

Paint Pouring Tool Kit (page 9)

Acrylic paints, 4 or 5 colors of your choice

Pouring medium of your choice

Silicone and other paint additives of your choice (optional)

Canvas

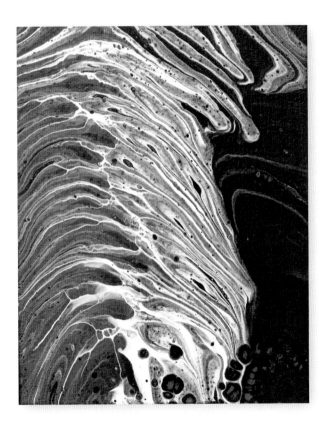

Colors used:
red, blue, yellow, black, white

1. With the instructions and recipes on pages 13–15, combine your paints with your chosen pouring medium and paint additives, mixing each color in a separate cup. Add your premixed paints to a new cup in any order that you want **(A)**. Keep the color palette simple, and remember that the first color you add to the cup will be the last color you pour out. It's better to use layers of contrasting colors in your cup and to use small amounts of many colors than large amounts of fewer colors for this technique.

2. Pour the paint slowly, starting on one side of the canvas and using a very slight circular motion **(B)**. Move across the canvas to the other side with the paint in this fashion, leaving some paint in your cup. Once you have reached the other side, add the remaining paint by traveling back through the paint you have already poured, until you have poured all the paint out of your cup and returned to the side of the canvas where you started **(C)**.

3. Slowly tilt the canvas vertically to cover it with paint **(D)**. The paint will begin to drip off the sides as you tilt. You may need to tilt in other directions to cover the canvas fully, but try to only tilt vertically as much as possible for this technique. Remember to tilt slowly; you don't want too much paint to run off the canvas or you may lose your design.

4. Once complete, set the painting on a level drying area **(E)**. Let the paint dry for at least a week, clean off any silicone, if needed, and seal it (see Finishing Your Painting, page 17).

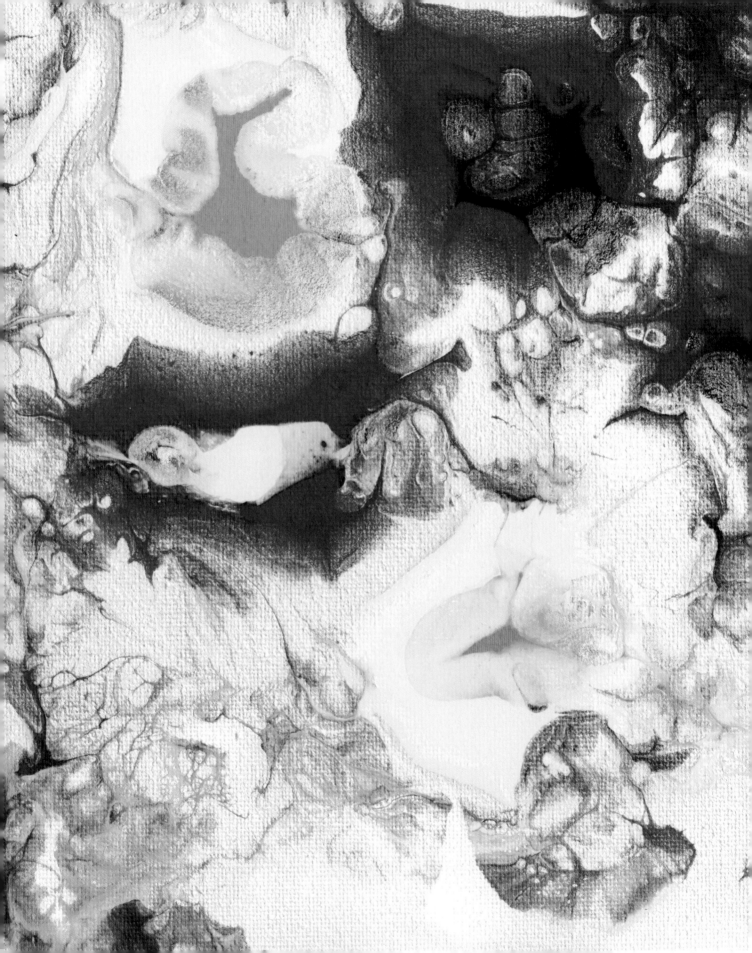

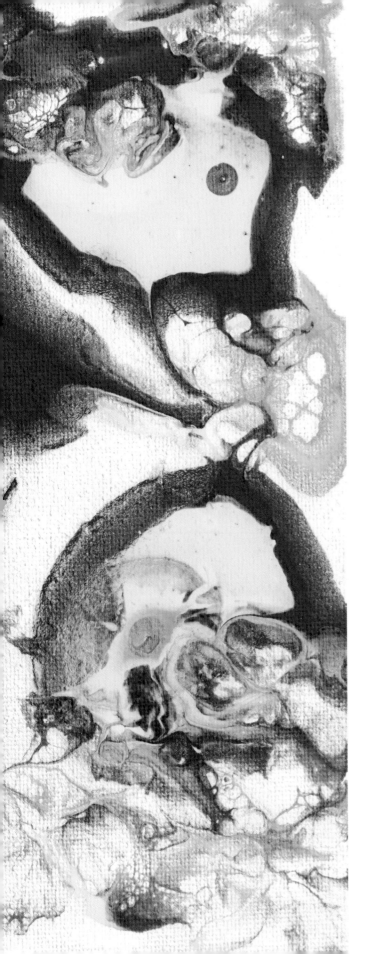

BALLOON SMASH

This technique uses the natural suction of a balloon against the canvas to create flowerlike designs and patterns. While this name includes the word smash, it should really be called a balloon touch or a balloon kiss; you want to be gentle when touching the balloon to the canvas.

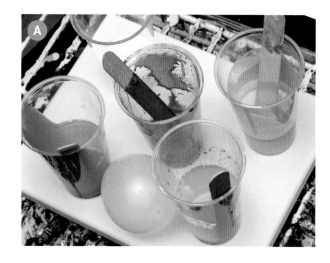

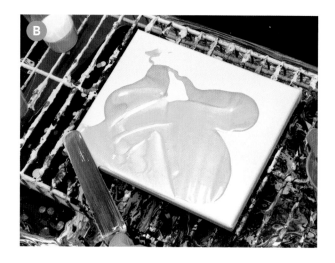

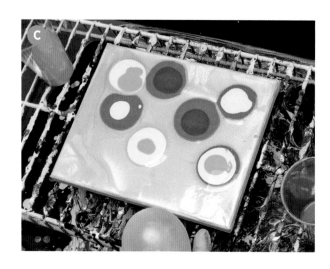

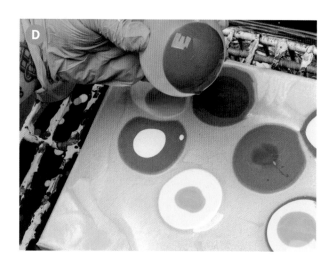

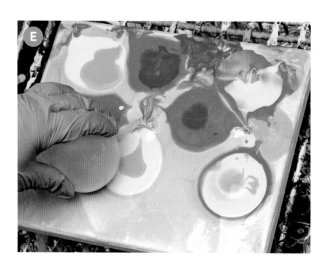

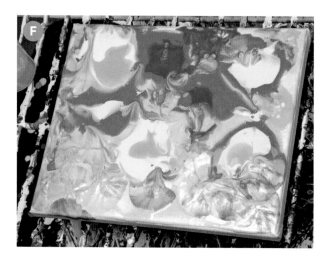

WHAT YOU NEED

Paint Pouring Tool Kit (page 9)

Acrylic paints, 4 or 5 colors of your choice

Pouring medium of your choice

Silicone and other paint additives of your choice (optional)

Canvas

Inflated balloon

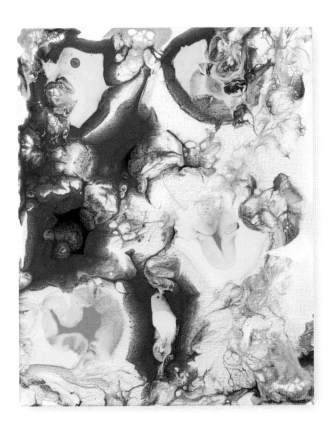

Colors used:
silver, yellow, green, blue, purple

INSTRUCTIONS

1. With the instructions and recipes on pages 13–15, combine your paints with your chosen pouring medium and paint additives, mixing each color in a separate cup **(A)**.

2. Cover your canvas with an even layer of paint in a solid color. Pour the paint onto the canvas, then move it around with a scraping tool, such as an offset spatula, or by tilting **(B)**. Usually white or another neutral color works best.

3. Using three or four colors, pour your paints into small puddles in various spots on the canvas **(C)**. You don't need to use a lot of paint, as you will be spreading it around with the balloon.

4. Gently press your balloon into a puddle and then lift it straight up **(D)**. Press the balloon into the background color and lift up, then touch it back down into another puddle. Repeat until you've created a design you like **(E)**. There are no rules to this—just have fun with it! You can clean the balloon off in between dips or just keep going, which will mix the colors more.

5. Once complete, set the painting on a level drying area **(F)**. Let the paint dry for at least a week, clean off any silicone, if needed, and seal it (see Finishing Your Painting, page 17).

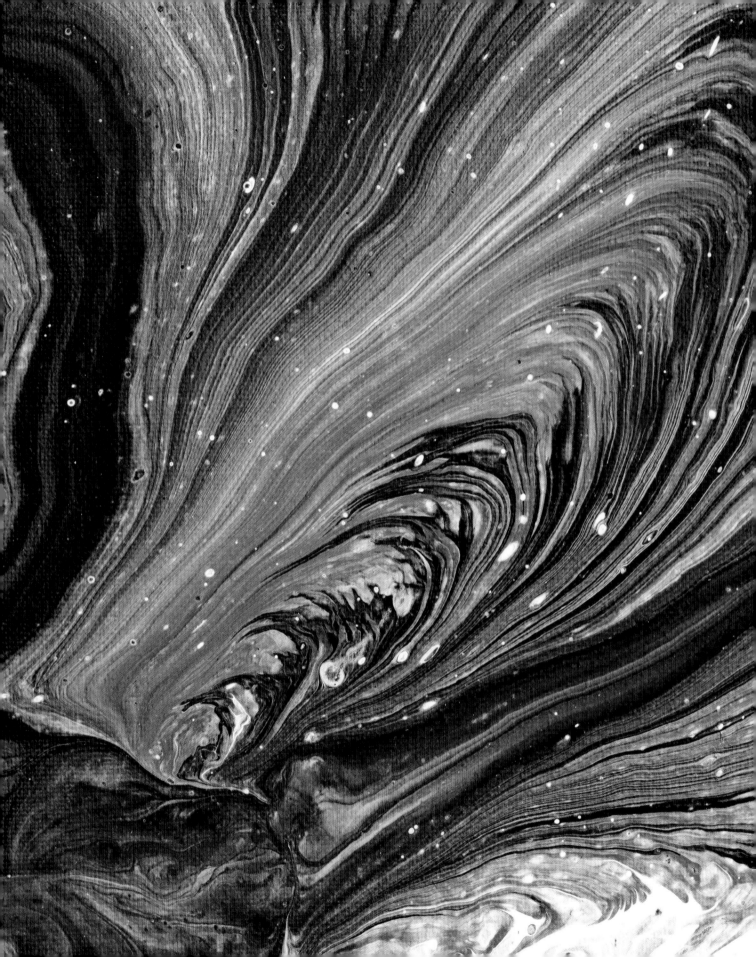

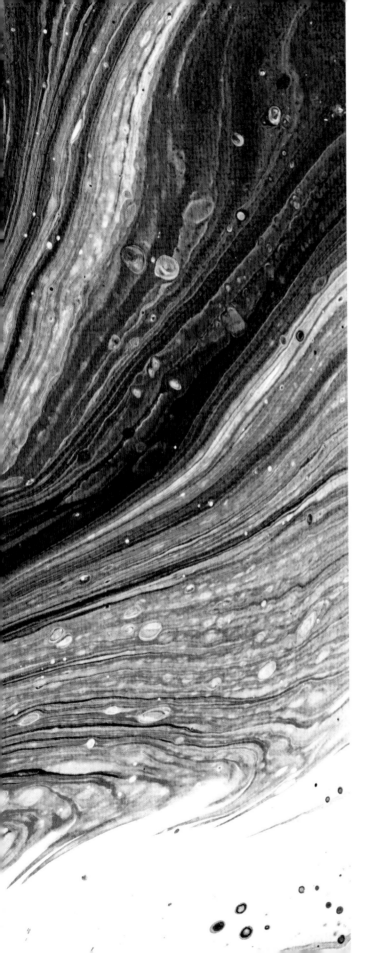

BOTTLE BOTTOM POUR

Many plastic soda bottles have a fun starlike design on the bottom with five points. With this technique, you'll utilize that design and pour in between the points to create a very exciting pattern. Though this technique can be done as a clean pour, it usually works best as a dirty pour, as shown here.

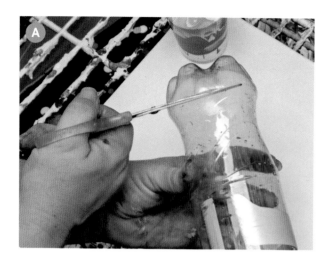

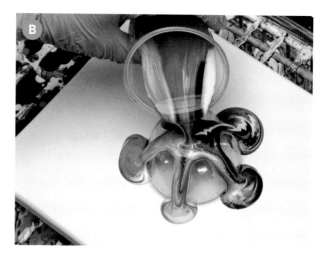

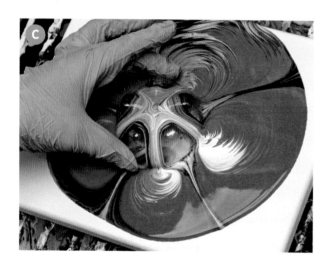

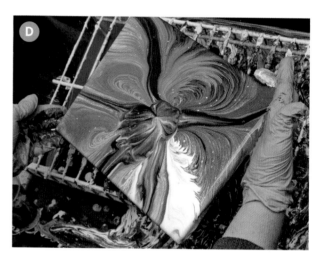

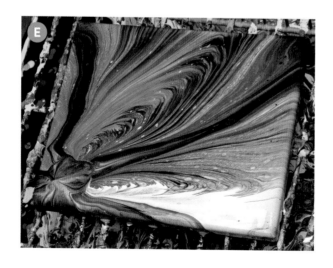

WHAT YOU NEED

Paint Pouring Tool Kit (page 9)

Acrylic paints, 4 or 5 colors of your choice

Pouring medium of your choice

Silicone and other paint additives of your choice (optional)

Scissors or a craft knife

Plastic soda bottle

Canvas

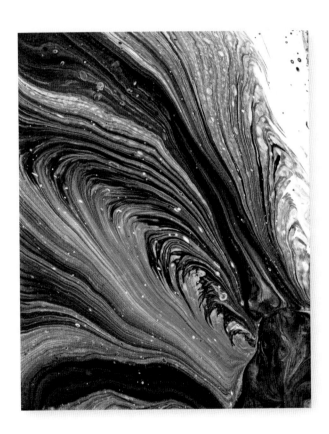

Colors used:
red, orange, yellow, black, white

INSTRUCTIONS

1. With the instructions and recipes on pages 13–15, first combine your paints with your chosen pouring medium and paint additives, mixing each color in a separate cup. Then add your premixed paints to another cup in any order that you want. Keep the color palette simple; no more than 5 colors works best. With scissors or a craft knife, carefully cut off the bottom of a soda bottle, cutting as evenly as possible **(A)**.

2. Place the bottom of the bottle in the center of your canvas, cut side down. Slowly pour your paint into its center **(B)**. The paint will flow through the ridges around the points of the bottle bottom and onto the canvas, creating a flowerlike pattern. Continue until you have poured out all of the paint from your cup. Gently lift the bottle bottom off of the canvas and set it aside **(C)**.

3. Slowly tilt canvas in a circular motion to cover it with paint **(D)**. The paint will begin to drip off the sides as you tilt. To cover the corners, tilt the canvas directly toward each corner. Remember to tilt slowly; you do not want too much paint to run off the canvas or you may lose your design.

4. Once complete, set the painting on a level drying area **(E)**. Let the paint dry for at least a week, clean off any silicone, if needed, and seal it (see Finishing Your Painting, page 17).

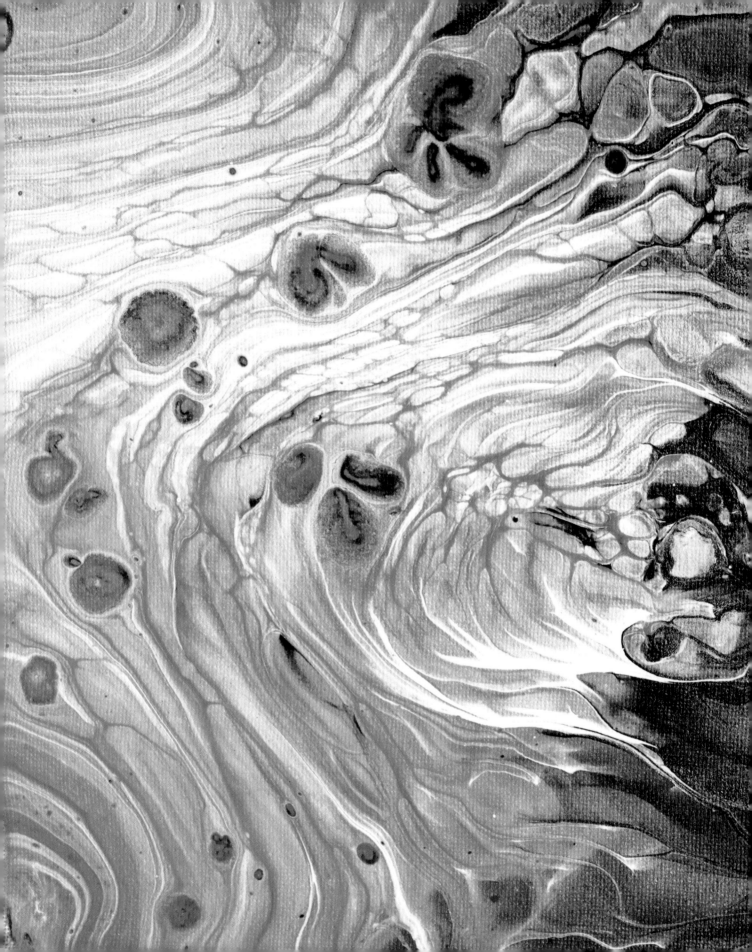

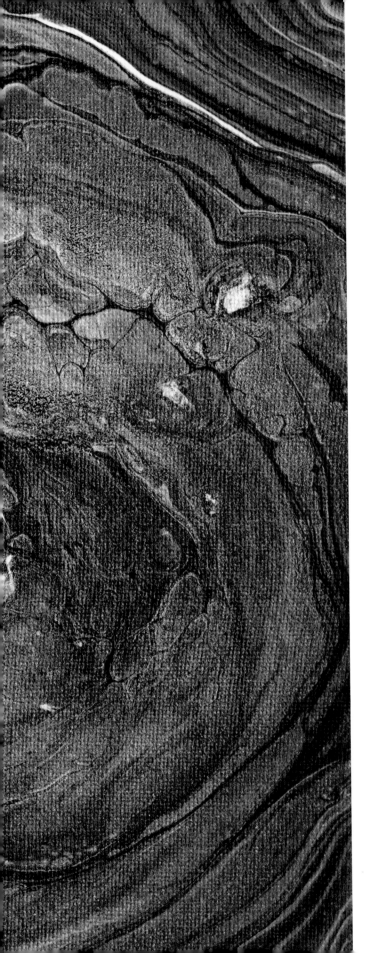

KISS POUR

Another fun take on the Tree Ring Pour (page 39) is the Kiss Pour. This technique uses two cups, poured simultaneously, to create a two-toned tree ring with contrasting colors. The important thing about this technique is to pour the cups at the same pace and have the paints touch midstream as you pour.

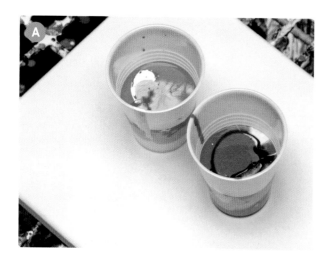

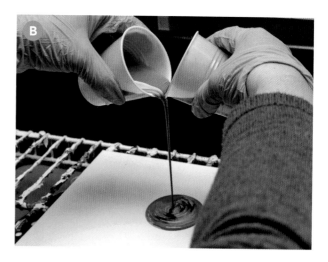

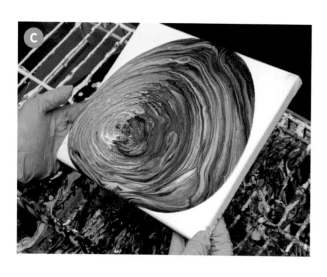

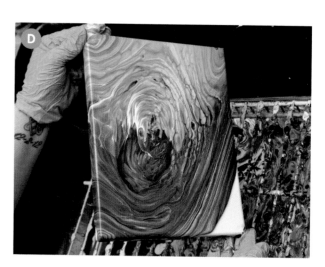

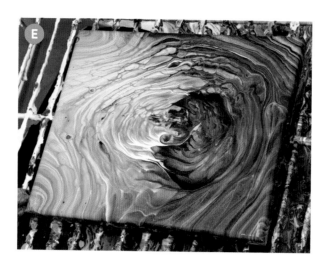

Paint Pouring Tool Kit (page 9)

Acrylic paints, 8 to 10 colors of your choice

Pouring medium of your choice

Silicone and other paint additives of your choice (optional)

Canvas

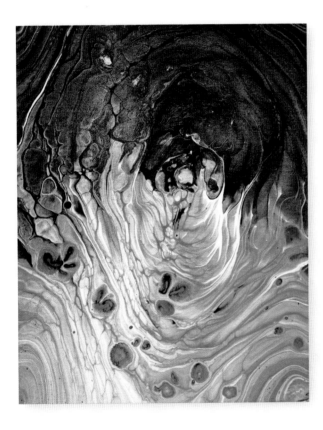

Colors used:
Cup 1—blue, white, purple, silver; cup 2—orange, yellow, red, black

1. With the instructions and recipes on pages 13–15, combine your paints with your chosen pouring medium and paint additives, mixing each color in a separate cup. Divide the paint between two cups, choosing four or five colors for each one **(A)**. Fill each cup up with half the amount you need for your canvas size (see page 14). It's ideal to use contrasting colors. For example, fill one cup with dark colors and the other with light colors. Using small amounts of many colors is better here than using large amounts of fewer colors. Remember that the first color you add to the cups will be the last color you pour out.

2. Holding a cup in each hand, slowly pour them simultaneously, ensuring the paints touch or "kiss" midstream **(B)**. Continue in this fashion until both cups are empty.

3. Slowly tilt the canvas in a circular motion to cover the canvas with paint **(C, D)**. The paint will begin to drip off the sides as you tilt. To cover the corners, tilt directly toward each corner. Remember to move slowly; you do not want too much paint to run off the canvas or you may lose your design.

4. Once complete, set the painting on a level drying area **(E)**. Let the paint dry for at least a week, clean off any silicone, if needed, and seal it (see Finishing Your Painting, page 17).

Paint Pouring on Objects

Once you get started with acrylic pouring, you will usually find yourself wondering what else you can pour on besides canvas. The answer is just about anything! I have done acrylic pouring on furniture, vases, ornaments, sawblades, vinyl records, wooden boxes, picture frames, and more. My general rule? If it sits still, you can paint it!

If you're pouring on anything that will be outdoors, keep in mind that weather and light can affect paint, so it won't necessarily be durable. Additionally, keep paint away from any surfaces used for food as it is toxic, and you don't want to eat it.

I've compiled a few of my favorite acrylic pouring projects. These projects are easy and fun, and can be completed with items that might already be lying around the house or those that you can purchase inexpensively from a thrift store, general store, or garage sale near you.

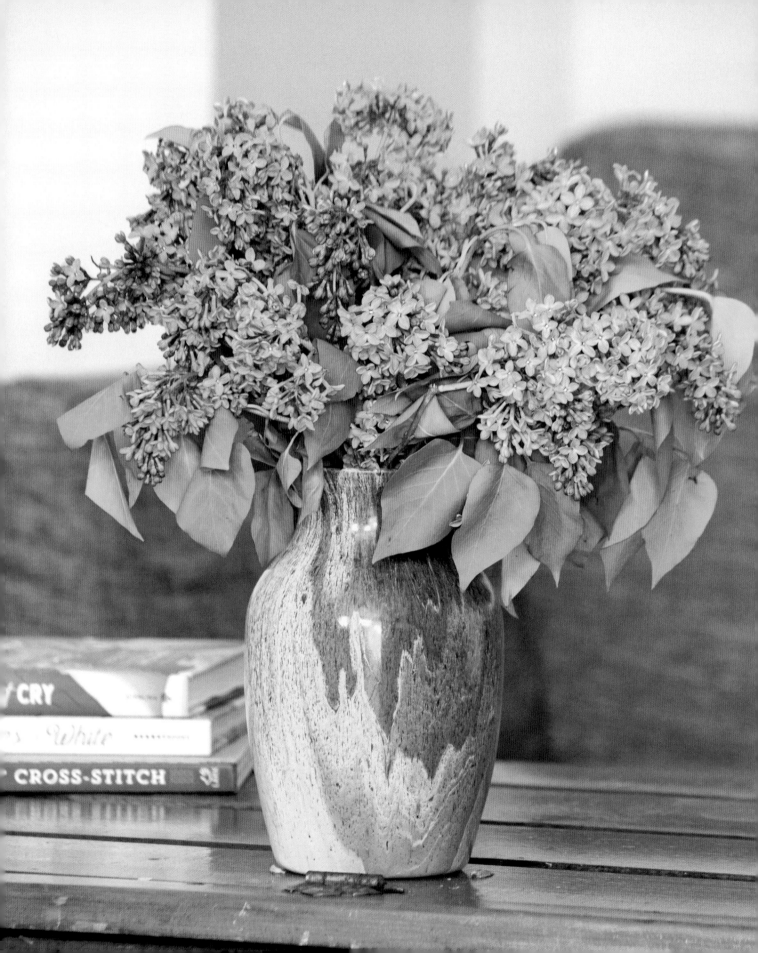

VASE

Vases are so simple to pour on, and your friends won't believe that you painted this beautiful piece yourself! To save paint, I like to put a canvas or other paintable surface under my vase as I pour, making this an awesome two-in-one project. It is best to use a vase with a flat bottom so that the paint doesn't puddle in the middle. You'll also want a vase with an opening that is wide enough to fit onto a cup to make painting easier and allow you to move it as needed.

WHAT YOU NEED

Vase

Isopropyl alcohol

Paper towel or cloth

Plastic cup for holding your vase

Canvas

Paint Pouring Tool Kit (page 9)

Acrylic paints, 4 or 5 colors of your choice

Pouring medium of your choice

Silicone and other paint additives of your choice (optional)

INSTRUCTIONS

1. Prepare your vase for painting by cleaning it thoroughly with isopropyl alcohol and a paper towel or cloth. (Fingerprints can prevent the paint from sticking to the glass.) Place a plastic cup on top of your canvas, and set your vase upside down on top of the cup so that the vase is raised from the canvas **(A)**. About half of the cup should fit into the vase.

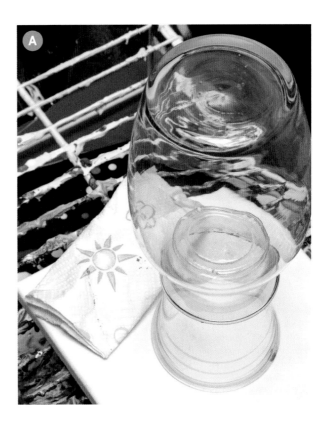

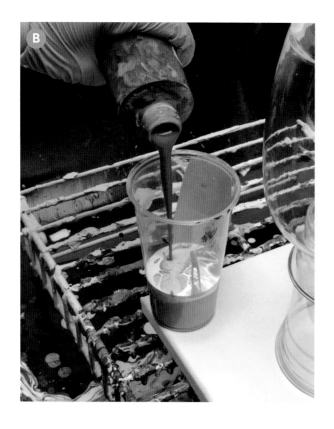

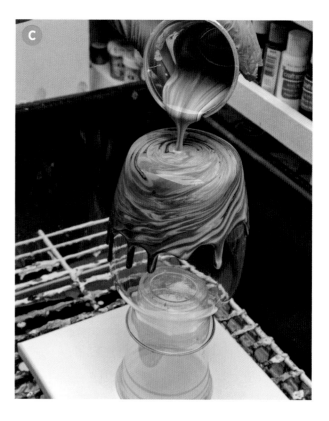

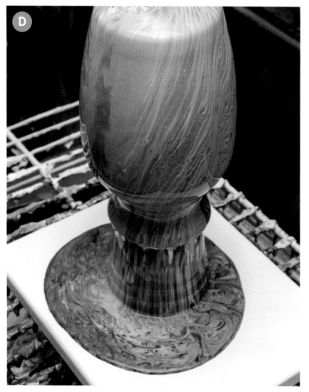

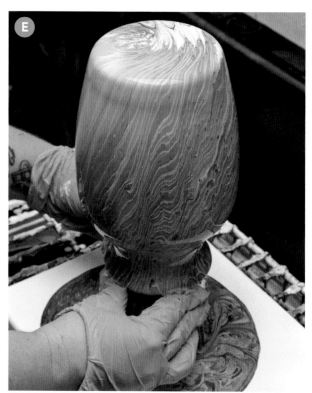

2. With the instructions and recipes on pages 13–15, combine your paints with your chosen pouring medium and paint additives, mixing each color in a separate cup. Layer your paint colors in a clean cup in any order, using the amount of paint that you would need for the canvas that is sitting under your vase **(B)**. It will be enough paint to cover both items.

3. Pour the paint slowly onto the bottom of the vase in a circular motion until you have used all of the paint in your cup **(C)**. The vase should be fully covered at this point, but if not, add more paint to cover any empty spots. You can also gently use your finger to move paint into the empty spots. Because the paint will keep moving for a while, this will easily get blended in.

4. Leave the vase on the canvas until the paint has mostly stopped dripping **(D)**. This usually takes about 5 to 10 minutes. Lift the vase up using the cup on which it is sitting and carefully move it aside to dry **(E)**. Tilt your canvas until it is covered with paint **(F)**.

5. Allow your painting and vase to fully dry, remove any silicone, if needed, and seal per the instructions on pages 18–19.

TIP: *I recommend sealing your vase with more than one layer of varnish. I prefer using three or four coats of enamel spray, which will make the vase much more durable and prevent chipping. The vase can be hand-washed gently— never soak or run it through a dish-washer.*

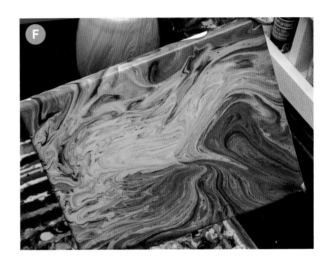

Colors used:
blue, turquoise, pink, white, black

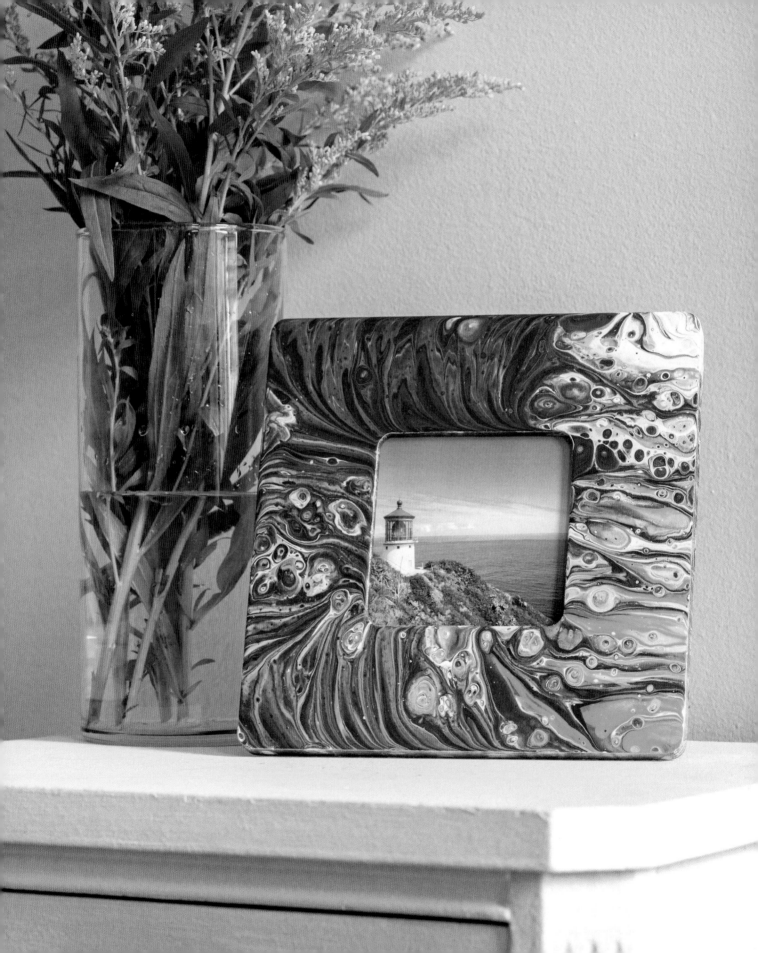

PICTURE FRAME

Paint pouring on a picture frame can be a great way to renew an old, scratched frame and can also be a great project to make with inexpensive picture frames from your local dollar store or craft store. You can use any of the acrylic pour techniques on your frame and any colors to match your home décor.

WHAT YOU NEED

Picture frame

Primer or gesso

Paint Pouring Tool Kit (page 9)

Acrylic paints, 4 or 5 colors of your choice

Pouring medium of your choice

Silicone and other paint additives of your choice (optional)

INSTRUCTIONS

1. Remove the glass and backing from the picture frame. Prepare your picture frame by painting its surface with primer or gesso **(A)**. Let this fully dry (it usually only takes about 30 minutes).

2. Choose any pouring technique and paint your frame **(B)**. I recommend the Traveling Tree Ring Pour (page 43).

3. Let your picture frame fully dry and seal it per the instructions on pages 18–19. Replace the glass panel if there is one, insert your photo, and replace the backing.

Colors used:
red, yellow, blue, white, black

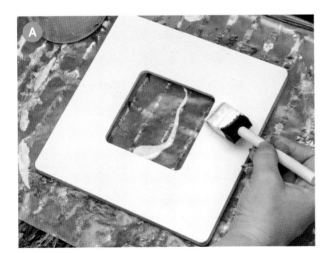

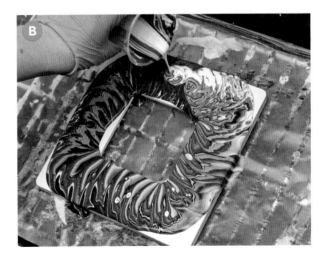

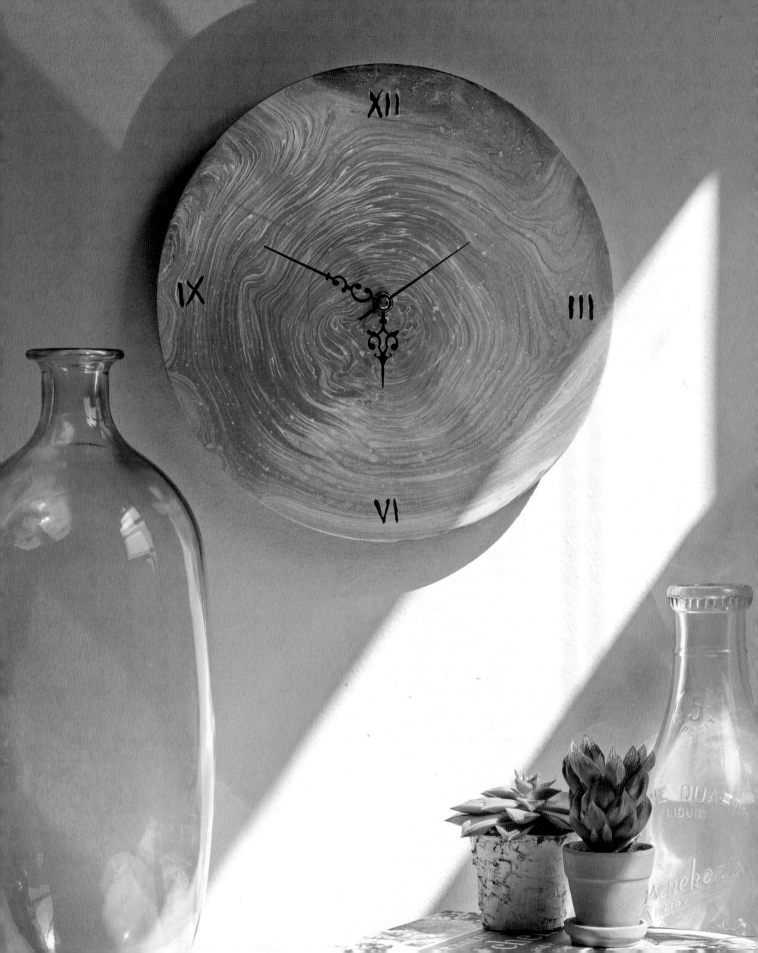

VINYL RECORD CLOCK

Vinyl records are an inexpensive and unique paint surface. You may have records lying around that are scratched and no longer play, or you can get some from a music or secondhand store. I have found records to be the perfect size and shape for a beautiful clock that you can paint to match any home décor.

WHAT YOU NEED

Vinyl record

Primer or gesso

Painter's tape

Paint Pouring Tool Kit (page 9)

Acrylic paints, 4 or 5 colors of your choice

Pouring medium of your choice

Silicone and other paint additives of your choice (optional)

Clock mechanism

INSTRUCTIONS

1. Prepare the vinyl record by painting it with primer or gesso **(A)**. You can either remove the label on the record or paint right over it.

2. On the back side of the record, cover the hole in the middle with a piece of painter's tape **(B)**.

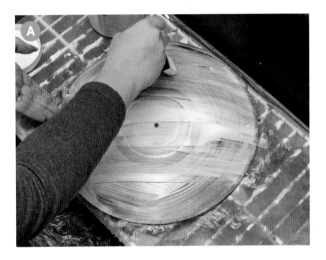

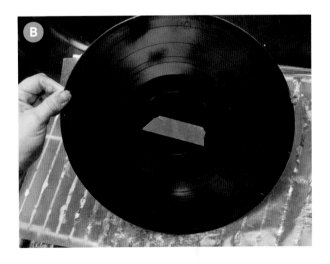

3. With the instructions and recipes on pages 13–15, combine your paints with your chosen pouring medium and paint additives, mixing each color in a separate cup. Choose any technique to paint your record, treating the record as your canvas **(C, D)**. I've used the Tree Ring Pour (page 39).

4. Let your vinyl record fully dry, remove the tape, and seal it per the instructions on pages 18–19. Once the sealer has dried, insert a clock mechanism into the hole in the middle of the record according to the manufacturer's directions. Most clock mechanisms come with hangers that you can use to display your clock. You can hand paint numbers on the clock face or use stickers. (Some clock kits even come with numbers.)

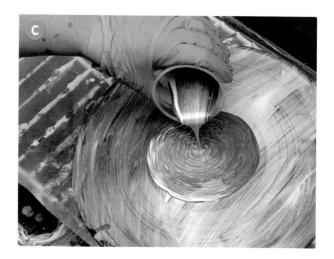

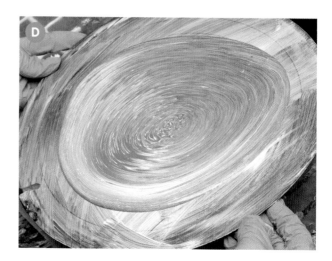

Colors used:
red, gold, blue, turquoise, white

ACRYLIC SKIN ART PROJECTS

You will often have runoff from your acrylic pours, especially when you are tilting your projects to cover them with paint. This runoff can be saved by placing wax or parchment paper under your project before you begin. The paper will catch the excess paint that you tilt off of your canvas, and once dry, it can be used in other projects or simply framed on its own.

This thin layer of dried paint is known as an acrylic skin. It is flexible and can easily be cut into shapes. A thinner acrylic skin will be slightly stretchy, whereas a thicker acrylic skin will be more brittle, so you'll want to be gentle with handling them and lay them between sheets of parchment paper until you're ready to use them. I recommend letting them dry for a full week or more before using them to ensure that the paint is cured and your project will turn out properly.

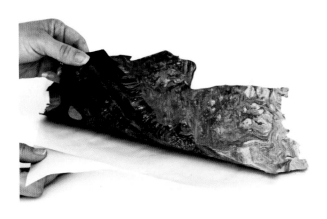

Here are some ideas for projects you can make with acrylic skins:

JEWELRY

Using a hole punch or scissors, cut your acrylic skins so that they easily fit inside a clear bezel. Seal it with resin or a piece of glass to make necklaces, bracelets, earrings, and more.

BOOKMARKS

Using scissors or a paper cutter, cut your acrylic skin into a rectangle and laminate it with clear tape, contact paper, or a laminating machine. Punch a hole in the top and thread a ribbon or string through it.

BOOK JACKET

Make a unique jacket for your books by pasting your acrylic skin onto contact paper. Simply cut the contact paper to fit your book and then cover your book with it. If you don't have one acrylic skin that is large enough, you can make a collage with several smaller pieces.

MIXED MEDIA ART

Acrylic skins make an excellent background for a mixed media painting. Simply glue the skin to your art surface and paint or add more objects directly on top. You can also cut out pieces of acrylic skins and use them to create extra layers and visual interest on your mixed media piece.

STICKERS

Paste your acrylic skin onto contact paper and then use scissors or punches to create stickers in any size and shape desired.

MAGNETS

To make some fun magnets, glue acrylic skins directly onto flat magnet sheets and then cut out any shapes you want. You can also glue the acrylic skins to the back of clear glass pieces and then glue a magnet on the back.

Troubleshooting

My paint colors are turning to mud.

When your colors blend together too much, it means your paint is too thin and the colors aren't able to stay separate, or you've moved the paint around too much. Try using less water in your mixture. This can also happen if you tilt the canvas too much, especially if you did not use enough paint. Refer back to page 14 to ensure you are using enough paint and make sure you are not over-tilting your canvas.

I didn't use enough paint to cover my canvas.

If you find that you did not use enough paint to easily cover your canvas, there are two things you can do. One is to first add more of an individual color directly to spots without paint and then tilt your canvas to blend in the new paint. Alternatively, you can add a combination of all your colors to your cup and pour this mixture on the blank areas, tilting your canvas to blend.

My painting cracked as it dried.

There are a couple of reasons a painting can crack as it dries. The most common culprits are that your paint is too thick or you left too much of it on the canvas. Thin your paint a little more with water or pouring medium.

Another reason could be that your painting is drying too fast, meaning the top layer of your paint dries much faster than the bottom layer, causing the top layer to shrink and crack. I find this to be less common; however, try to make sure your drying environment isn't extremely hot and dry.

My paint is pulling away from the edges of the canvas.

This can happen if your paint is too thin or you have a slack canvas. If your canvas is slack, meaning if it's sagging at all in the middle, tighten it up by spraying the back with water and letting it dry. Make sure you spray the corners. If it is not your canvas, it means that your paint is too thin. Try using less water in your mixture.

I lose my amazing cells as my painting dries.

This often happens when the paint is too thin. You can make a beautiful-looking painting, but then as it's drying, it keeps moving, and keeps moving, and keeps moving, until you've lost your cells and design. Try using less water in your mixture.

My painting was vibrant when wet but dull or darker when dry.

This is a very common problem, particularly if you're using matte or craft paints. Varnishing it (or sealing it with resin or enamel) should bring out the vibrancy of the colors again. Black can also occasionally take over paintings. If your paintings are drying quite dark, take care to use less black.

I don't like my painting, and I want to paint over it.

If you did not use oils, you can just apply a layer of gesso and paint right over it. If you used oils, you will have to clean off all the oil first, let it dry, apply a layer of gesso, and then paint over. If you don't clean the oil off, it's highly likely that your new layer of paint will craze, meaning it will crack. Refer to page 18 for how to clean off the oil.

I just can't get cells in my painting.

This is usually the main frustration of someone starting out with acrylic pouring. While I wish there was a foolproof way to tell people how to get cells every time, I just haven't found that to be possible. So much depends on the paint you're using, the medium you're using, and how you mix your paint.

What I will say is that when you get the consistency right, you will know it. If your paint is muddy, the consistency is not right. If you're not getting cells, the consistency is not right. If your paint is cracking, the consistency is not right. Luckily, all you usually need to do in most cases is to alter the amount of water you're using. Following the basic recipes on page 14 should get you the best results.

If you keep that in mind, you'll be much closer to solving the problem than if you try out tons of different paints, mediums, and additives. Alter your recipe slightly as you go until you've found your perfect one. Once you have it, you will have vibrant colors, beautiful cells and patterns, and paintings that you are satisfied with.

Glossary

ACRYLIC POUR Also called pour painting or fluid painting, this is a method of abstract painting using the fluidity of paints to make various abstract patterns and cells.

ARCHIVAL Archival in reference to art means it's durable and meant to last. For example, using craft paint and school glue produces a painting that is not archival. Certain products are designed to be archival, though you should be safe if you stick to quality paints and mediums.

BINDER A binder is a substance that will hold particles together. Pouring medium acts as a binder for the paint so that it holds together properly and doesn't crack or craze.

CELLS Organic, roundish shapes created in the paint by air bubbles or differences in paint densities.

CLEAN POUR A clean (or straight) pour is any acrylic pouring technique in which you apply the paints directly to the canvas, as opposed to pouring them into a cup and then onto the canvas. Examples of clean pours are the Puddle Pour (page 51) and the Swiping technique (page 47).

CRADLE The wood frame under the top of a wood panel is called a cradle. Cradles have different depths and can be used to hang the panel.

CRAZING This refers to the process when the top layer of your paint dries too fast, resulting in small cracks throughout your painting.

DIRTY POUR A dirty pour is any acrylic pouring technique where you put the paints together into a cup before applying them on the canvas, such as a Flip Cup (page 27) or Tree Ring Pour (page 39).

GESSO Gesso is a primer for paintings. You would use it to prime and seal your canvas before painting, though many canvases come pre-primed. Gesso is usually white, but it is also available in clear and in black.

MDF Short for medium-density fiberboard, MDF is an engineered wood product made by breaking down wood fibers, combining it with binders, and applying high temperature and pressure to form flat panels. It is commonly used to make wood panels.

NEGATIVE SPACE Negative space is the space around, or in between, the main subject of an art piece. It is most often a solid, neutral color or contrasting color.

PIGMENT Pigment is the coloring in paint. It can be organic or synthetic, and depending on what type of paint you get, there will be more or less pigment in it. Higher quality paints have more pigment; lower quality paints have much less pigment.

POSITIVE SPACE Positive space refers to the main subject or focus of a photo or art piece.

POURING MEDIUM In acrylic pouring, a pouring medium is anything you mix with the paint to bind it and make it more fluid, such as glue or latex-based paint conditioner.

PVA GLUE PVA stands for polyvinyl acetate. Some PVA glues are considered archival, meaning they won't yellow, will last a lot longer, and won't break down over time. Other PVA glues, such as school glue, are not archival and are not made to last.

RESIN Resin is often used to seal an acrylic pour, as it can make colors pop and the paintings much more durable. This clear liquid comes in two parts, which are mixed together to cause a chemical reaction. This chemical reaction allows it to dry clear and very solid, like plastic.

SWIPE Any acrylic pour technique (page 47) in which you gently drag one layer of paint across others. This can be done using a variety of tools, including cardboard, paper, and plastic.

VISCOSITY *Viscosity* is a term used to describe how a liquid will flow or the consistency of paint for acrylic pouring. A liquid that is thick will flow more slowly and, therefore, is said to have a higher viscosity or to be more viscous.

Resources

I love to shop local and support small businesses to purchase my art supplies wherever possible. You can also often find surfaces for pouring as well as your other tools, such as colanders and funnels, at thrift stores and garage sales. If locally owned shops near you don't carry the supplies you're looking for, here are some suppliers where you will be able to acquire the items you need.

Canvas, Paints, and Pouring Mediums

MICHAELS
michaels.com

HOBBY LOBBY
hobbylobby.com

BLICK ART MATERIALS
dickblick.com

CURRY'S ARTISTS' MATERIALS
currys.com

AMAZON
amazon.com

WALMART
walmart.com

Pouring Mediums and Silicone

LOWE'S HOME IMPROVEMENT
lowes.com

THE HOME DEPOT
homedepot.com

AMAZON
amazon.com

DULUX PAINTS
dulux.ca

Stir Sticks, Cups, Funnels, and Other Tools

AMAZON
amazon.com

WALMART
walmart.com

Acknowledgments

To all artists and creatives in the world: don't let anyone ever tell you that you or your art are not good enough. Believe in yourself and know that you can make it.

This book is dedicated to my mom, LaVonne, and to my second mom, Mary. I am so blessed and lucky to have had two amazing mothers who were both such beautiful, kind, caring women. Thank you both for making this family and this world a better place.

I would like to thank my wonderful husband, Johnnie. He has been with me every step of the way on my art journey, through my ups and downs, bad days and good days. Johnnie, I love and appreciate you more than I could ever express in words.

I want to thank my amazing dad, Carl. Since birth, he has been my biggest cheerleader. He has always given me the freedom to pursue my dreams and always made me believe that I could do and be anything I ever wanted. Without my amazing parents and family, I wouldn't be the person I am today or have the guts to keep going and know that everything will, in fact, be okay.

Thank you to my sisters, Michelle, Melanie, and Monique, and my brother, Mitchell. I know we're all crazy, but that's what makes us so awesome. Despite anything that happens, we always have each other's backs, and that's a great feeling. I want to thank my daughter, Sierra, for being the most adorable, beautiful, sweet, amazing human being I've ever met. I love you, Boo Boo.

I want to thank Dynnel, Kara, and Krissi. You beautiful ladies are the best friends anyone could possibly have in the world. I love that I can always go to you for help and advice, and you guys still keep answering the phone when I call—usually.

As always, thank you to my YouTube subscribers and followers. Your successes and excitement about creating acrylic pours and art are what keep me going and make my heart so happy.

Lastly, thank you so much to my photographer, Tim Sabatino; my editor, Elysia Liang (you're awesome); and the rest of the team at Sterling, including Jennifer Bossert, Jaime Chan, Shannon Plunkett, and Chris Bain. Without you, this book would literally not be possible.

Index

About the Author

Marcy Ferro is a full-time artist, born and raised in Los Angeles. Marcy began drawing at a very young age and painting with oil paints around the age of six. She took every art class available at school, including sculpting, drawing, painting, dance, acting, and many others in the wide field of the arts.

Around 2007, Marcy began practicing with acrylic paints and became enthralled with mixed media. She began creating custom portraits and mixed media paintings for friends and family, and her career as an artist began to grow.

Marcy is now the owner of the successful and growing YouTube channel Mixed Media Girl, where she teaches acrylic pouring and other art techniques with video tutorials. She also teaches others how to make a business with their art through her YouTube channel The Business of Art, and is the author of *Mixed Media Girl's Tips for YouTube Success*.

In addition to running her YouTube channels and art business, Marcy, along with her husband, Johnnie, is the owner of The Painter in You, a company that teaches painting classes in Southern California, and Grunge Artist Apparel, which makes unique handmade clothing. She currently resides in Los Angeles with her husband and daughter.